IMAGES
of America

ITALIANS IN
LOS ANGELES

IMAGES
of America

ITALIANS IN
LOS ANGELES

Marge Bitetti

ARCADIA
PUBLISHING

Published by Arcadia Publishing
Charleston SC, Chicago IL, Portsmouth NH, San Francisco CA

Printed in the United States of America

Library of Congress Catalog Card Number: 2007923838

For all general information contact Arcadia Publishing at:
Telephone 843-853-2070
Fax 843-853-0044
E-mail sales@arcadiapublishing.com
For customer service and orders:
Toll-Free 1-888-313-2665

Visit us on the Internet at www.arcadiapublishing.com

This book is dedicated to the memory of my grandparents (Nonno) Vito and (Nonna) Mary Colombo, aunt (Zia) Filippa and uncle (Zio) Sam Colombo, and all those who endeavor to keep the Italian culture alive and vibrant to pass on to future generations. Cuor forte rompe cattiva sorte, or "Nothing is impossible to a willing heart."

CONTENTS

ACKNOWLEDGMENTS

Writing this historic overview covering so many years would not be possible without the assistance and cooperation of many people. Unfortunately, it is not possible to provide details of all the people and businesses that should be listed. I wish to publicly acknowledge the following individuals and organizations that granted permission to include photographs: St. Peter's Italian Church; Fr. Raniero Alessandrini, C. S., Fr. Giovanni Bizzotto, C. S., and Donna Angiuli; consul general Diego Brasioli; Dr. Gloria Ricci Lothrop; Dr. Carlo Chiarenza; Johnny Angiuli; Anthony Angiuli; Richard Alessandro; Tony Bitetti; Vito Colombo; Mary Colombo; Alejandra Armas DeLuca; Jimmy DeSisto; Stefano Finazzo; Rochelle Giuseffi; J. B. Griffin; Emil Mor; the Garibaldina M. B. Society; David Mendoza; Steve Marabella; Steve Nuccio; Dominic Orlando; Sebastiano Piazza; Paul Politi; Suzanne Politi; Ann Potenza; Mary Colombo Schulz; Rosalie Colombo Trisler; Maryann Zamboni; and anyone else that I might have forgotten. Zamboni® and the configuration of the Zamboni® ice resurfacing machine are the registered trademarks of Frank J. Zamboni and Company, Inc. The Leo Politi family holds the copyright to the information regarding Leo Politi. All rights are reserved.

FOREWORD

Starting in the late 1870s and for the following 100 years, over 27 million people left Italy to settle across the sea in other countries and continents. According to a report compiled by the order of Sons of Italy in America, more than 15.7 million people with Italian ancestry live in the United States. California is home to over 1.4 million of them. Los Angeles ranks fourth in the country as home to Italian Americans—surpassed only by New York, Chicago, and Philadelphia. In Los Angeles, their homes are spread across a vast urban area covering 33,954 square miles and over 4,800 miles within the heart of the city.

The Gold Rush of the 1850s brought many people to California seeking silver and gold. Those that did not find gold in the soil discovered the richness of climate for farming and other opportunities in the southern part of the state. The train depot at Union Station in downtown Los Angeles was a point of entry for thousands of people who came West. In 1910, traveling from the East Coast to California cost approximately $120. At the time, this was equivalent to a year's salary for many of the newly arrived immigrants. After the 1930s, the improved automobile provided a more affordable method for the journey to Los Angeles. A large number of Italian Americans, including war brides and second- and third-generations, settled in Greater Los Angeles after the end of World War II.

Italians had immigrated to Los Angeles from all regions of Italy; the first settlers were primarily from the north but were then joined by many from the southern sections. Many were skilled in trades or professions and others were craftsmen or artisans. These brave people brought with them their love of family, culture, and fine Italian food and wine. Despite memories of the beautiful country they had left, the settlers shared a zest for life and a willingness to make America their new home.

The collective terms Southland or Greater Los Angeles explain the sprawl that has long been associated with the growth of Los Angeles. As the city expanded, subdivisions were born but still remained linked to the mother city. The original core of the Italian community in Los Angeles covered the area from Union Station to Chinatown. An area that is today known as Olvera Street was once the center of the Italian community. Many wineries operated in downtown Los Angeles, but as a result of the Volstead Act of 1919, which provided the enforcement of Prohibition, these businesses were mostly abandoned. The thriving Italian community then disbursed to the neighborhoods surrounding the core of the city, stretching from the mountains east of Santa Monica to the port of Los Angeles in San Pedro.

The rich history of the Italians who worked and sacrificed to make a living in Greater Los Angeles is vast and cannot be told in a few photographs and pages of text. This book is intended to spark the interest of the reader and perhaps encourage further reading and research on the subject.

INTRODUCTION

In Los Angeles, Italy is very much alive—through its fashion, design, food, and its many scientists and researchers at the most prestigious universities. Italy is also present in three of the great landmarks of Los Angeles: the visionary Watts Towers, built by the Italian artist Simon Sabato Rodia; the Getty Center, with its "travertine" marble from Tivoli; and the Walt Disney Concert Hall, with its curvaceous titanium-steel shell designed by Frank Gehry and entirely made in Italy, as well as its elegant, exhilarating interiors. Moreover, the new Los Angeles County Museum of Art (LACMA) is being designed by internationally acclaimed architect Renzo Piano.

A few miles from Los Angeles, the NASA Jet Propulsion Laboratory in Pasadena connects every day to the two Rovers, which are exploring the surface of Mars and the Cassini probe around Saturn, thanks to a sophisticated receiver-transmitter system made in Italy and managed by young Italian researchers.

The history of Hollywood is strongly connected to our country, with 12 Oscars (from Federico Fellini and Sofia Loren to Roberto Benigni and Ennio Morricone) won by Italian artists, without counting all the Italian American actors and filmmakers such as Sofia and Francis Ford Coppola, Martin Scorsese, Al Pacino, Robert De Niro, and Leonardo DiCaprio, among others. And what shall we say about the famous singers Frank Sinatra, Madonna (Ciccone Ritchie), Tony Bennett (Antonio Dominick Benedetto), and Dean Martin (Dino Crocetti)?

Los Angeles speaks, eats, sings, and dresses Italian.

Yet the Italian presence in the city and in the West goes back centuries when explorers and immigrants ventured to visit and colonize the promising westernmost frontier of the New World.

This book brings to the surface the adventure of the Italians in Los Angeles, shedding new light on several aspects and episodes of a story not yet very well known by the general public. Marge Bitetti's research is a must for all those who want to understand the role played by the Italian immigrants in making Los Angeles "the most multicultural city of the world," as constantly defined by Mayor Antonio Villaraigosa.

—Consul General Diego Brasioli

Italian Consul General to Los Angeles Diego Brasioli, pictured here, has graciously provided the introduction to this book. (Courtesy Diego Brasioli.)

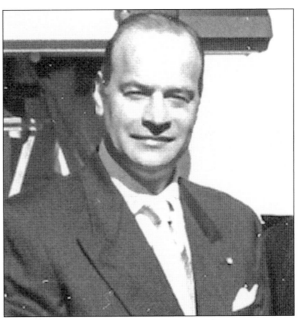

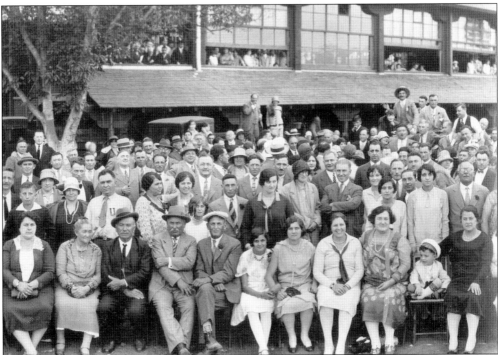

Italian American organizations flourished in the 1920s when the growing number of immigrants joined together to celebrate Italian cultural and traditions. Pictured are members of the Garibaldina Society M. B. Some of the larger Italian American organizations that carry on the Italian heritage include the National Italian American Foundation (NIAF), The Sons of Italy, National Organization of Italian American Women, and UNICO, which is the largest Italian American Service organization in the U.S., taking its name from the Italian word for unique. (Courtesy Garibaldina Society.)

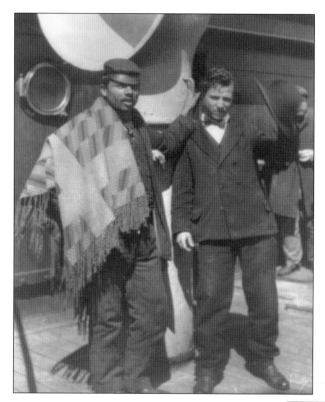

Unidentified Italians arrive at Ellis Island around 1910. The main ports for arrival were New York, New Orleans, and later San Francisco. The trip from Italy to Ellis Island cost between $35–50 per person. According to historian Gloria Ricci Lothrop, the cost to travel from Italy to California was approximately $120—a year's income for most people. Early exploration of California and the Gold Rush helped bring people West to seek their fortune. (Courtesy Library of Congress.)

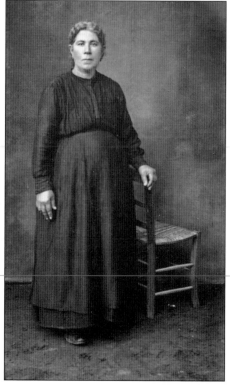

Marie Garofalo Colombo, pictured about 1890, had four sons and two daughters. Two of the sons left Italy for South America and two left for the United States, ending up in Los Angeles. Often when families separated they were never able to reunite because of the cost. Travelers coming to California had to pay nearly $80 in addition to the initial ticket to New York or New Orleans. They worked their way west doing a variety of jobs and acquiring skills, learning how to blend into the American lifestyle. Some came to California to join other relatives or friends—*paesani*—from Italy. (Author's collection.)

One

THE BEGINNING

Italians came to America for many reasons: to escape poverty and the illnesses spreading across Europe, to join friends and family who were already enjoying new opportunities living in the new land. The California Gold Rush and the railroads brought many people West. Most of the Italians who migrated to Los Angeles did their move slowly, laying down roots in various states along the way and taking jobs in coal mines, on the railroad, and in agriculture. More educated newcomers found their way in education, the arts, and engineering.

Italians who settled in Los Angeles were different than their counterparts on the East Coast. There was actually less ethnic prejudice in Southern California. As a result, people did not feel the need to live in ethnic enclaves and instead seized the opportunity to own land in surrounding areas. Thus, the tight-knit communities familiar in other big cities with large Italian populations were absent in Los Angeles.

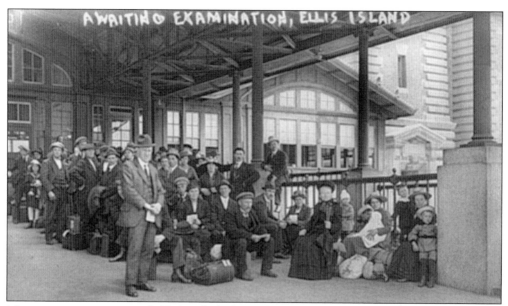

Most immigrants were crowded below decks for weeks without privacy, food, or proper ventilation. They brought with them only what they were able to carry. When they arrived at Ellis Island, they were tagged and had to check their baggage and endure health examinations by immigration officers. Fourteen million Italians arrived in the United States between 1876 and 1914. Giovanni Leandri settled in Los Angeles by way of Peru in 1823 and opened a store selling merchandise and liquor. (Courtesy Library of Congress.)

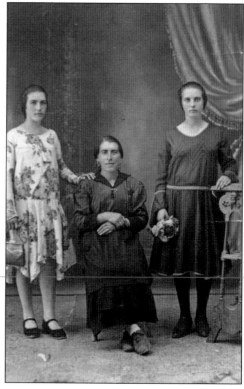

An unidentified woman is pictured with her daughters around 1910. Photographs like this were sent from relatives in Italy to the family members who had immigrated to the United States. By the 1900s, the agriculture business was booming in Southern California, bringing in large of crops of lemons, oranges, and grapes. Los Angeles was the wine capital of California. Secondo Guasti, Giovani Sormano, and Antonio Pelanconi were leaders in the growing wine industry. (Author's collection.)

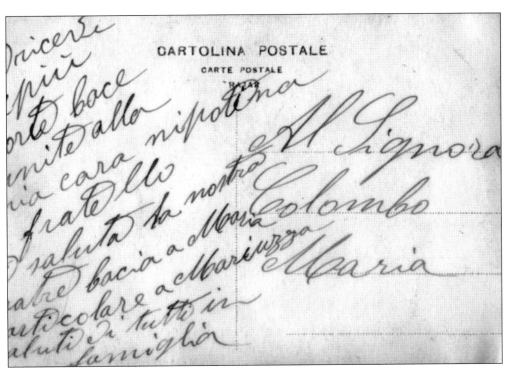

CARTOLINA POSTALE
CARTE POSTALE

When families separated, the only memories that they had were the photographs that they brought to America with them, along with infrequent letters and postcards. Brief notes on photo postcards were exchanged to let relatives know that family members were in good health. (Courtesy Mary Colombo Schulz.)

Pietro and Rose Durzo, seen about 1920, immigrated to Pennsylvania from Calabria, Italy. Eventually Pietro's niece Maria Durzo Colombo settled in Los Angeles. The first Italian immigrants, from Piedmont and Tuscany, were involved in agriculture. Many fishermen came from Ischia and Sicily. Italians arriving in Los Angeles from 1910 through the 1930s worked in produce production, the movie industry, and goods and clothing manufacturing. (Courtesy Mary Colombo Schulz.)

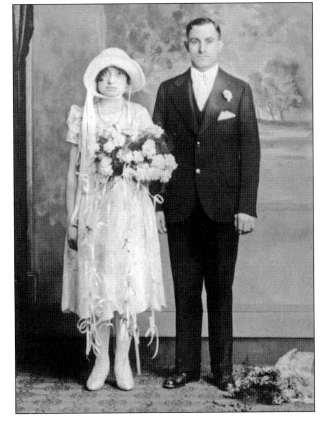

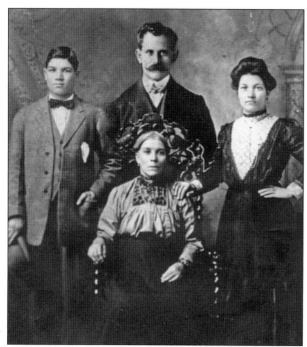

This unidentified Italian family is an example of those who would have gone to the Italian Hall in the early 1900s. The historic hall was the center of activity in the growing Italian community in Los Angeles. Located at the end of Olvera Street in the El Pueblo section of the city, it was the site for social gatherings, dances, weddings, and meetings of the Italian Mutual Benevolent Society and the Garibaldina Society. Many Italian-owned businesses and wineries were located on Olvera Street, just across from the main train terminal at Union Station. The oldest building in Los Angeles, the Avila Adobe, was once the Hotel Italia Unita. (Author's collection.)

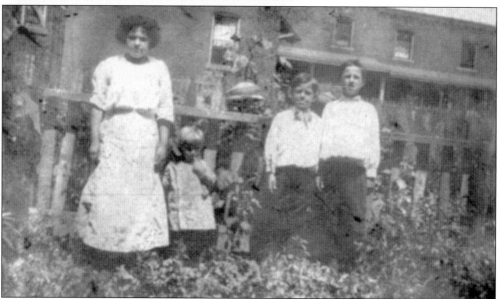

The Italian Hall, built by Pozzo Construction in 1907, served the Italian community until 1931. The Volstead Act of 1919 enforced that any beverage containing half of one percent of alcohol was against the law, which caused most of the wineries in downtown Los Angeles to close and other businesses in the area to relocate. Since most of the wineries were owned by Italians, the closure ordered by the Volstead Act caused an economic hardship on all of the businesses. Italians moved out of the area to seek other work. There was no longer a need to the Italian Hall because the Italian population moved to other neighborhoods. The Depression also brought economic hardship. Many Italians families at least had their own gardens, which allowed them fruits and vegetables to use in cooking. (Courtesy Mary Colombo Schulz.)

Constructed between 1855 and 1857, the Pelanconi House was the first brick home in Los Angeles. It was named after owner Antonio Pelanconi, who operated a winery on Olvera Street with Giacome Tononi and Secondo Guasti. During the 1940s, many jobs were relocated to Los Angeles because of the defense industry. Besides the trains and ships, the family car aided many Italians in transmigrating the country. (Author's collection.)

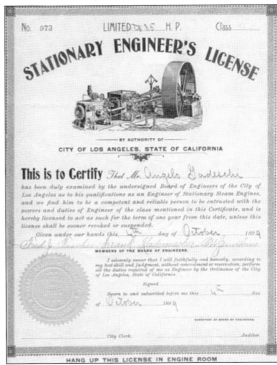

This stationary engineer's license, issued to Angelo Gadeschi, certified his right to work with steam engines. (Courtesy Nuccio family.)

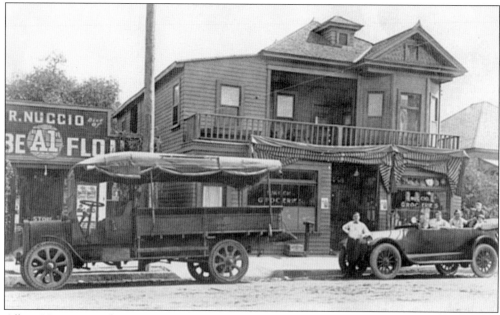

Albert Viotto started a grocery in approximately 1898. Robert Nuccio married Albert's daughter Mary, and upon Albert's death, Robert assumed management of the store. This photograph, taken at the grocery in 1923, shows Robert and Mary Nuccio; Mary's mother, Mary Viotto; John Nuccio; and Chel Nuccio. Shortly afterward, Robert sold the business to John Gadeschi and took his family back to Italy. John Gadeschi was born in Los Angeles in 1898. He was a friend and neighbor of Robert's on Hewitt Street, where there was a small enclave of Italians from northern Italy. Robert Nuccio eventually returned to America two years later when his wife became pregnant. (Courtesy Nuccio family.)

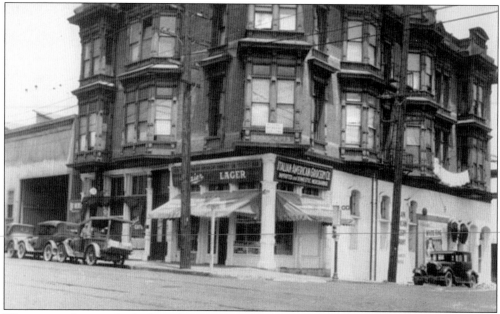

This image depicts the Italian American Grocery Company in the late 1920s. (Courtesy Nuccio family.)

Little Joe's Restaurant, pictured in 1928, became a downtown landmark for decades and was well known for delicious Italian food. (Courtesy Nuccio family.)

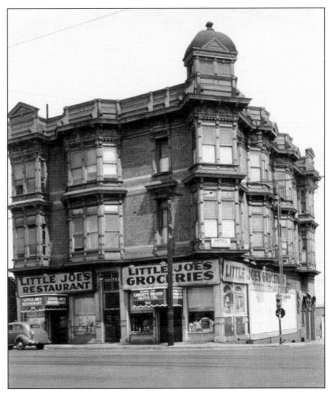

As a child, artist Leo Politi moved to Italy from Fresno with his parents. When he was in his 20s, he returned to California and resided near Olvera Street. He gained acclaim by painting the everyday sights he found in downtown Los Angeles. This is Politi's passport. (Courtesy Leo Politi family. All Rights Reserved.)

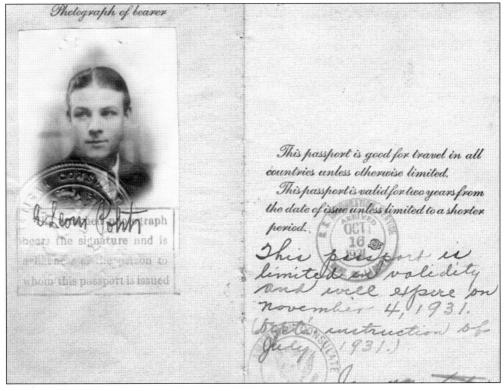

Photograph of bearer

This passport is good for travel in all countries unless otherwise limited.

This passport is valid for two years from the date of issue unless limited to a shorter period.

This passport is limited in validity and will expire on november 4, 1931. (by the instruction of July 1931.)

Leo Politi received a scholarship to study art at the Italian Art Institute. He went on to illustrate and write touching children's stories considered modern classics. His lively and colorful watercolors captured the hearts of Los Angeles residents. (Courtesy Leo Politi family. All Rights Reserved.)

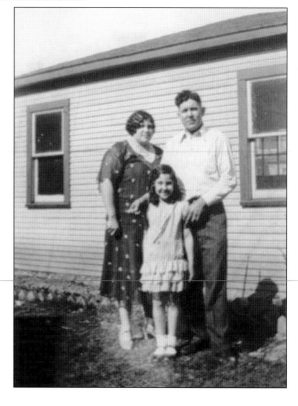

Mary and Vito Colombo are shown with their daughter Mary about 1930. Less than a decade later, the family would move to Los Angeles. Vito would become a successful businessman, and his wife would be known for her homemade bread, ravioli, Sicilian cannoli, and cassata desserts. (Courtesy Mary Colombo Schulz.)

Two

INNOVATORS AND TRENDSETTERS

An innovator is someone who thinks outside the box, someone who looks at a situation and is able to find new solutions. Innovative Italians have included such well-known names as Christopher Columbus, Leonardo da Vinci, Galileo, and Marconi. The Los Angeles area has had the good fortune of many daring leaders and trendsetters. Aviator Amerigo Balboni opened a flight school and the first used airplane part dealership in the country. The Bozzani brothers started a bicycle repair shop near downtown Los Angeles. Over time, this grew into a car dealership that still remains in operation. Although there are many more Italian Americans who deserve to be recognized, this chapter reviews a few of vision and courage who have seen ordinary things in novel ways to make life easier for future generations. This chapter reviews the outstanding Italian Americans whose contribution to the Los Angeles area has spread to the entire nation and the world.

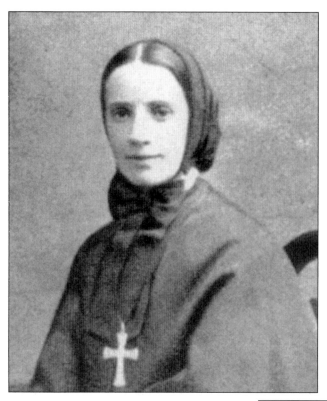

Mother Francesca Cabrini (1850–1917), also known as St. Frances Xavier Cabrini, was born in Sant'Angelo Lodigiano in the region of Lombardy and helped to found the Missionary Sisters of the Sacred Heart of Jesus. She wanted to do missionary work in China, but in 1889 she was sent by the Pope to New York to work with Italian immigrants. Cabrini became a citizen in 1909 and also became the first American to be named a saint—by Pope Pius XII in 1946. During her life, she established 14 colleges, 98 schools, 28 orphanages, and 8 hospitals, as well as other institutions. Mother Francis Xavier Cabrini established the Regina Coeli Orphanage in the hills north of Los Angeles, off Sunset Boulevard.

Amadeo Peter Giannini (1870–1949) was born in Northern California to Italian immigrants from Genoa. His father died when he was seven. Giannini helped his stepfather to build a prosperous wholesale produce business and was able to retire when he was in his 30s. His second successful business endeavor was banking. In 1904, with $150,000 in funds from his stepfather and 10 friends, he established the Bank of Italy to serve the needs of immigrants. A branch was located in downtown Los Angeles. After the 1906 San Francisco earthquake, Giannini made loans on a handshake to anyone who wanted to rebuild. He pioneered home mortgages, auto loans, and installment credit. In the 1920s, he advanced money to fund the fledgling motion picture industry, which started United Artists studio and aided the careers of Charlie Chaplin, D. W. Griffith, and Douglas Fairbanks. His funding helped produce the animation classic *Snow White*. In 1930, Giannini's vision and leadership evolved into the development of the Bank of America. (Courtesy Bank of America Historical Collections.)

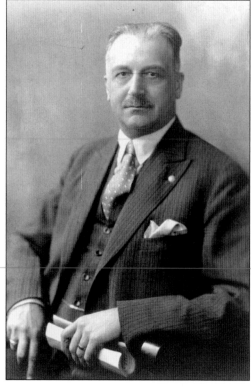

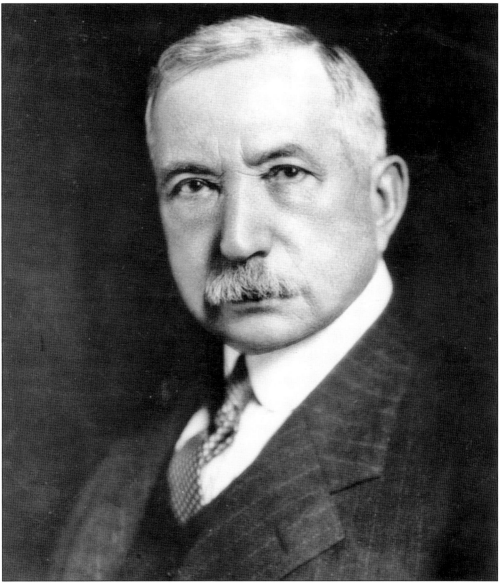

Joseph Francis Sartori (1858–1946), a second-generation Italian-German born in Cedar Falls, Iowa, became a prominent financier who was considered "the dean of Southern California banking." Sartori opened the Security Trust and Savings Bank in 1889 and founded the Security Pacific Bank of Los Angeles. Active in the community, he opened the first golf course in Los Angeles and helped in the formation of the Los Angeles Country Club. He helped to finance the building of the Biltmore Hotel and secured the real estate for the campus of UCLA. Sartori developed a charity model that allowed people to establish private charities under the guidance of a larger foundation. This method of charitable giving became the thriving California Community Foundation. (Courtesy Bank of America Historical Collections.)

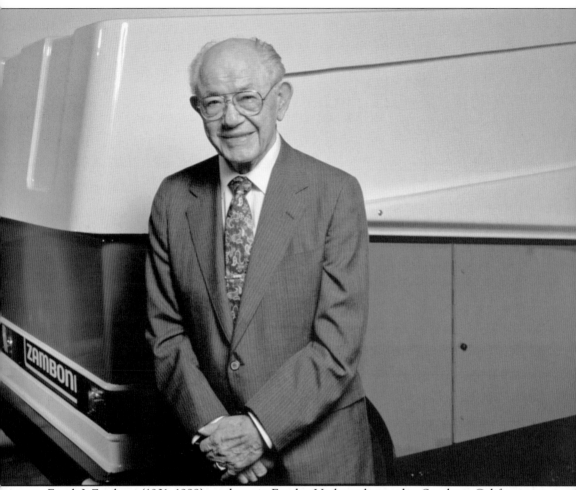

Frank J. Zamboni (1901–1988) was born in Eureka, Utah, and moved to Southern California in 1920. A hardworking entrepreneur and creative designer, he invented a machine to resurface ice that revolutionized indoor ice sports. Here he stands in front of a Zamboni® Model 500 in 1986. (Courtesy Frank J. Zamboni and Company.)

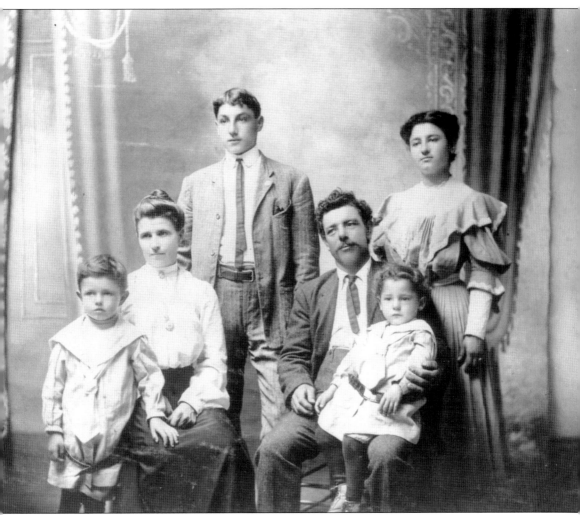

The family of Frank J. Zamboni gathers for a photograph around 1904. Pictured here are, from left to right, Frank; mother, Carmela; brother George; father, Frank Sr.; brother Lawrence; and sister Ida. (Courtesy Frank J. Zamboni and Company.)

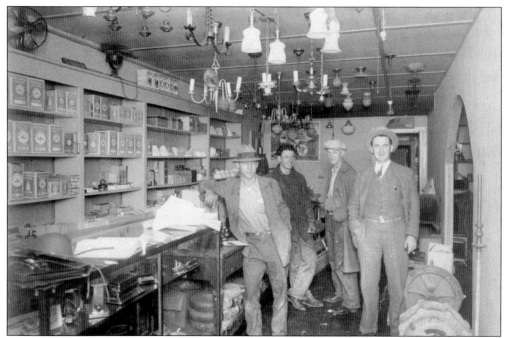

Frank Zamboni is seen in the newly opened Zamboni Brothers Electric. Fresh out of Utah, Frank (second from left) and his brother Lawrence (far left) opened an electrical shop in Hynes-Clearwater, twin towns that would later join as Paramount under Frank's leadership as president of the local Kiwanis Club. (Courtesy Frank J. Zamboni and Company.)

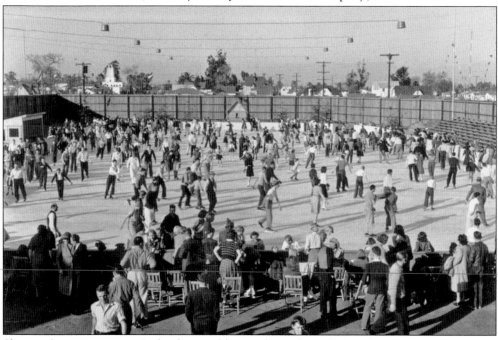

Skaters play at Paramount Iceland, owned by Frank Zamboni, before the installation of a roof. When the climate of Southern California proved poor for outdoor ice, Frank covered the arena just months after it opened. (Courtesy Frank J. Zamboni and Company.)

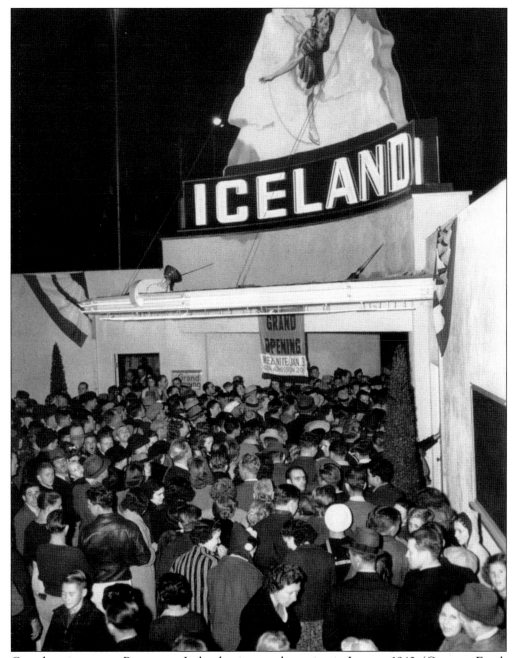

Crowds wait to enter Paramount Iceland at its grand opening in January 1940. (Courtesy Frank J. Zamboni and Company.)

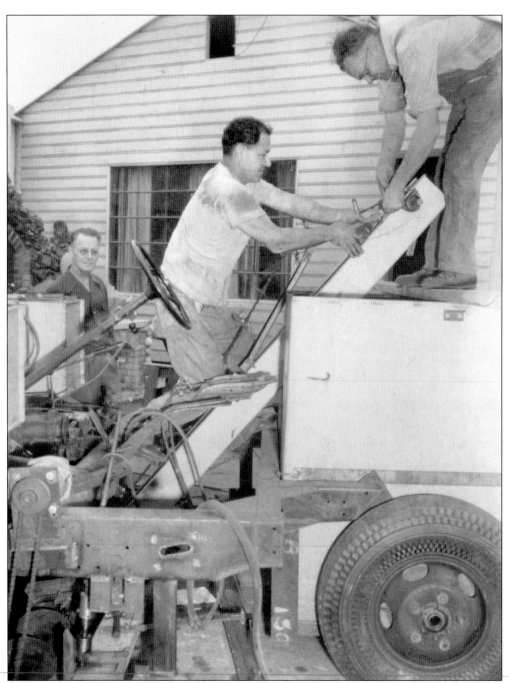

Frank Zamboni (center) gets help from Ross Chesebro as Ray Schloemer looks on. Beginning in 1942, Frank experimented with building an ice resurfacer, but his plans were foiled by the onset of World War II. In 1945, with the war over, he got back to work using military surplus parts. Prototype No. 3, pictured here, combined the necessary operations to smooth the ice—shave, remove shavings to the tank, wash, and squeegee—but its two-wheel drive lacked traction. (Courtesy Frank J. Zamboni and Company.)

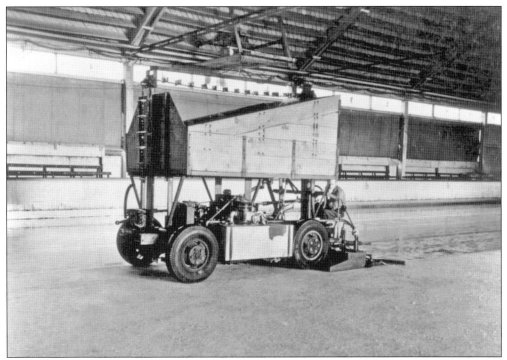

Frank Zamboni's first successful ice resurfacer, the Model A, operates at Paramount Iceland, with Lyle Cox driving. (Courtesy Frank J. Zamboni and Company.)

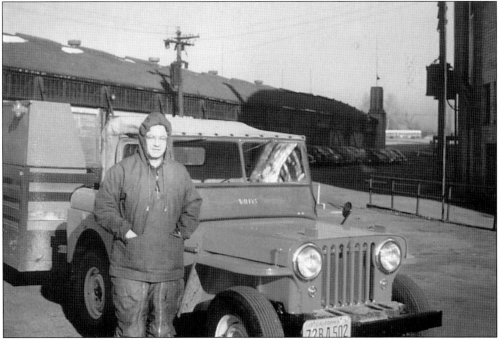

Here Frank is seen delivering Model B No. 2 to Sonja Henie in Chicago. Having loaded the parts in a trailer, he is towing them with the Willy's Jeep that would later become the body. (Courtesy Frank J. Zamboni and Company.)

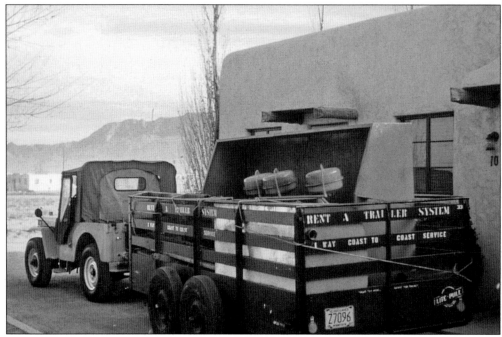

During the frigid winter of 1950, Frank Zamboni drove from California to St. Louis, then to Chicago, to personally deliver the ice resurfacer to international ice-skating star Sonja Henie. (Courtesy Frank J. Zamboni and Company.)

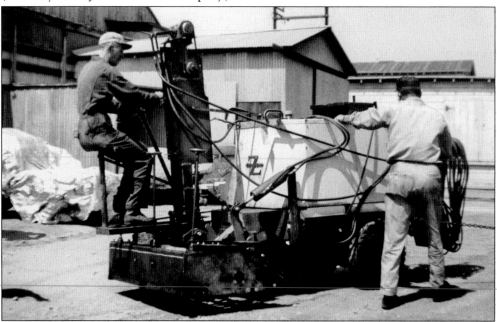

In 1963, Frank tested many variations of snow-conveying systems and traction drives while developing the Zamboni® Model HD, which was introduced in 1964. The Model HD featured a snow dump tank and an improved hydraulic system. This photograph shows one of the many prototypes tested at Paramount Iceland, which stood across the street from the manufacturing plant. (Courtesy Frank J. Zamboni and Company.)

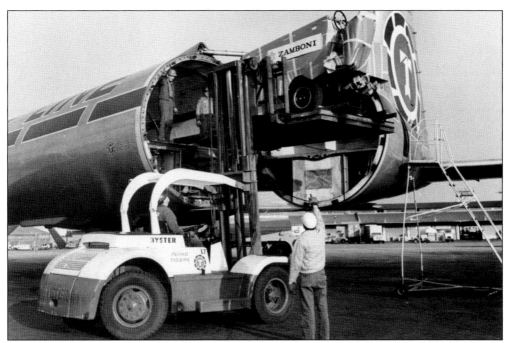

In 1968, Madison Square Garden in New York wanted its newly ordered Model K quickly and requested that it be shipped via airfreight. Here the Zamboni® is loaded into the rear of a Flying Tiger aircraft. (Courtesy Frank J. Zamboni and Company.)

Monsanto AstroTurf approached the Zamboni Company in 1970 to see if one of its ice resurfacers could be adapted to remove water from a baseball playing field, thereby avoiding postponement of the game. Because of the resurfacer's weight and other restrictions, an entirely new machine was designed, tested, and sold to the Monsanto organization. This photograph shows the initial test of the Astro Zamboni® at Busch Stadium in November 1970. Frank Zamboni, designer of the machine, stands on it during the test. (Courtesy Frank J. Zamboni and Company.)

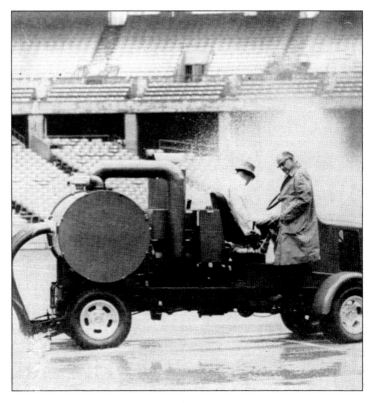

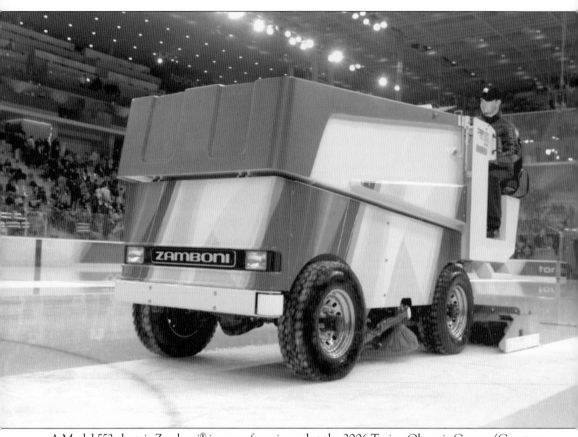

A Model 552 electric Zamboni® ice resurfacer is used at the 2006 Torino Olympic Games. (Courtesy Frank J. Zamboni and Company.)

Three

LIVELIHOOD

Italians brought skills and trades with them when they came to America. Many immigrants worked as pushcart peddlers, tailors, shoemakers, fishermen, ditch diggers, coal miners, masons, and tile setters. They were hardworking and determined to earn a living to support themselves and their families. In the early 1900s, Italian were the lowest paid workers in the country. On average, Italian laborers earned 25 percent lower than the average weekly wage of $14 per week but believed that with hard work they could improve their financial condition.

Immigrants who arrived in the United States after completing formal schooling secured jobs in various fields of education. Some excelled in business, sports, law enforcement, and government, such as Antonin Scalia, who was the first Italian American named to the Supreme Court, and Nancy Pelosi, the first woman and Italian American as Speaker of the House. Others excelled in the music and film, art, fashion design, and architecture industries. A large number of Italian Americans started and operated their own small businesses, paving the way for future generations.

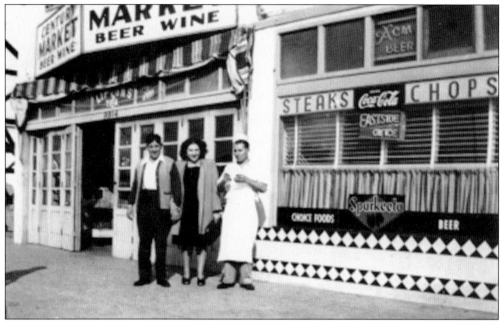

In the late 1940s, Vito Colombo and his wife operated the Century Market, an Italian market, deli, and café located near the corner of Century Boulevard and Vermont Avenue in Los Angeles. Pictured here are Vito Colombo (left), his daughter Mary Colombo (center), and Clifford Schulz, husband to Mary Colombo and the café chef. In the late 1950s, the property was sold and the land used for a chain supermarket. (Courtesy Mary Colombo Schulz.)

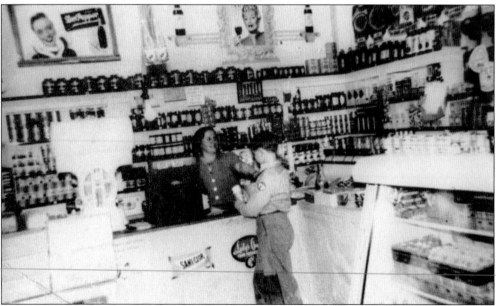

Proprietress Mary Colombo stands behind the counter of the Century Market while an unidentified boy makes a purchase. The market served the people of South Los Angeles from the late 1940s through the 1950s. Mary ordered products for the store, arranged the merchandise, managed accounts receivable and payable, and sold items to customers. Her husband, Vito, and daughter Mary assisted. (Courtesy Mary Colombo Schulz.)

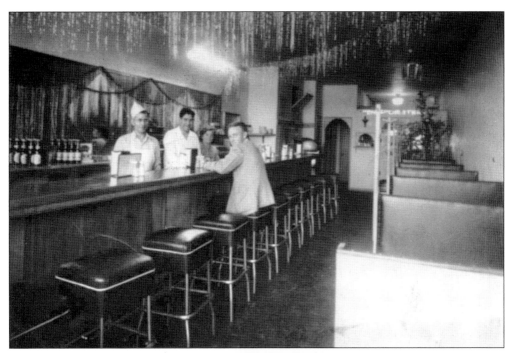

Adjacent to the Century Market was the Vermont Silver Dollar Café, also run by the Colombos. Seen here, from left to right, are Salvatore "Sam" Colombo, Vito Colombo, Filippa Colombo (Sam's wife), and an unidentified man on the bar stool. (Courtesy Mary Colombo Schulz.)

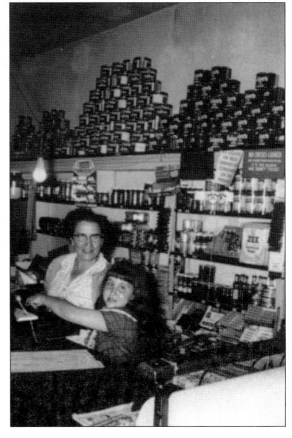

Rose Durzo (left), the sister of Mary Colombo, lived in Pennsylvania but when vacationing in California she helped at the Century Market. The granddaughter of the owner is helping herself to some cash. (Author's collection.)

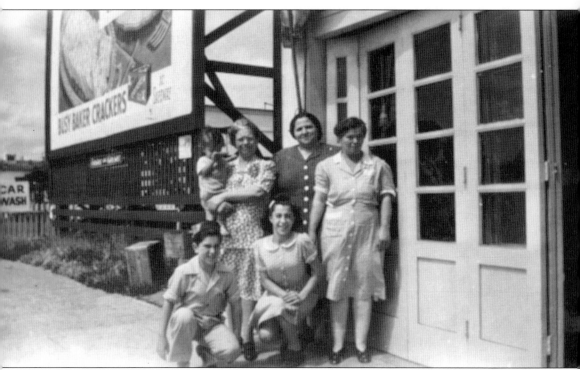

In the late 1940s, relatives sometimes visited from the East Coast. It was an occasion for the ladies to leave their duties in the family store and restaurant and pose for a photograph. Pictured here are, from left to right, (first row) Pete Colombo and his sister Rosalie; (second row) Grace Imbrunones (with her baby); Mary Durzo Colombo; and the children's mother, Filippa Colombo. (Courtesy Mary Colombo Schulz.)

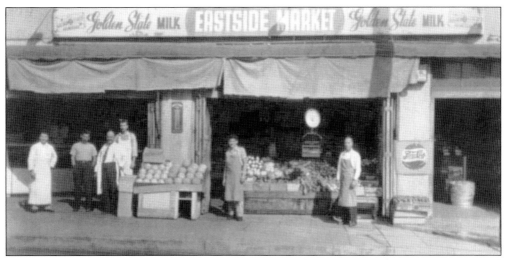

The Eastside Market opened on the east side of Los Angeles in 1929. At that time, it was owned and operated by Joe Campagna and Domenic Pontrelli. Though the ownership has changed through the years, the quality and charm remain today. (Courtesy Angiuli family.)

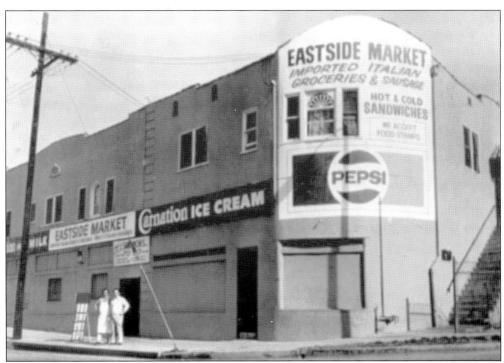

In 1959, Johnny Angiuli started as a clean-up boy for Pontrelli and eventually learned the butcher trade. In 1964, Johnny's brother Frank joined the Eastside Market as a driver. Johnny and Frank then became owners of the popular Los Angeles landmark in 1974. (Courtesy Angiuli family.)

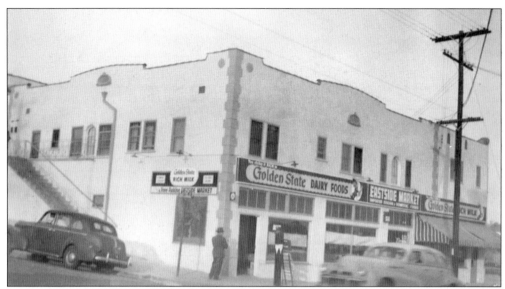

The building that is home to the Eastside Market and Italian Deli has been around for nearly 75 years. It was once on the border of the Italian neighborhood on a hillside that overlooks the Los Angeles City Hall and the Pasadena Freeway. Here an unidentified man stands outside the deli. (Courtesy Angiuli family.)

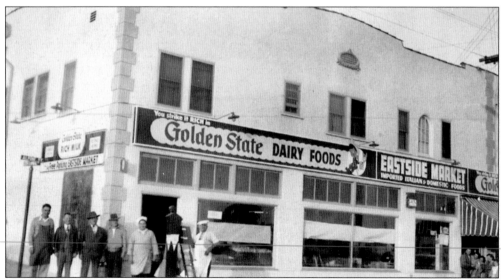

Unidentified crew members are pictured outside the Eastside Market, which was fashioned after a New York–style Italian deli. The family owned business has always served appetite-pleasing hot and cold sandwiches, cold cuts, and an assortment of other tasty treats. Over the years, it has been a common sight to see city workers and uniformed police lined up, waiting for meatball sandwiches loaded with Sunday-thick "gravy" and peppers. (Courtesy Angiuli family.)

Don Felipe (left) and his brother Johnny (center) are seen inside the Venice Baking Company. At the oven in the back is Larry Palmeri. The first bakery was located on Bronxdale Road in the Bronx, New York. By the early 1950s, Larry Palmeri had made his way west to the Los Angeles area and purchased a bakery in Venice Beach, hence the name Venice Baking Company. In 1969, construction was completed on a building in El Segundo, where the family continues to bake Italian bread and pizza crust. (Courtesy Jimmy De Sisto, Venice Baking Company.)

Frank Salerno (left), who went by the name "Mr. Frank," and Vito Colombo weigh produce on a scale. Vito was enterprising and charming. Since most of his customers were housewives who were not able to go out to the local markets to shop, he would drive through residential neighborhoods and ring the bell on his truck to announce his arrival. Vito's wife, Mary, made the awnings that hung from the truck and also balanced the receipts from his produce route. (Author's collection.)

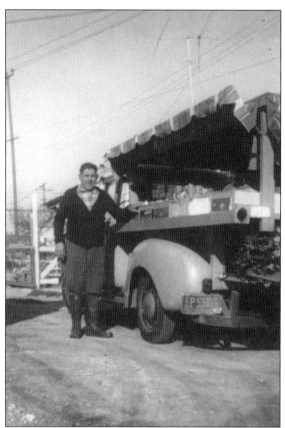

Vito Colombo proudly stands beside his truck. Each morning at 3:00 a.m. he would go to the downtown Los Angles produce market to purchase the fresh fruits and vegetables for the day. He would then return home to wash the sand and dirt off the produce and arrange it on his truck. After driving his truck through various neighborhoods for five to eight hours, he would refrigerate the items so that he could sell them the next day along with the new produce he would buy. (Author's collection.)

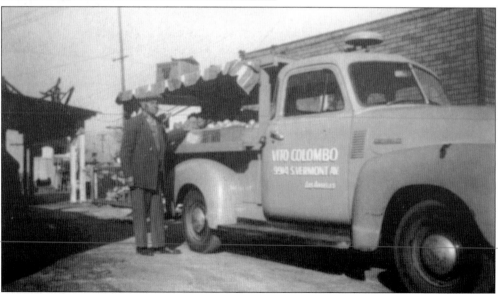

Frank Salerno is pictured standing next to a produce truck owned by Vito Colombo. After Vito and Mary Colombo sold the Century Market and the Vermont Silver Dollar Café, Vito earned a living selling produce. Although he did not have a formal education, the entrepreneur successfully owned and operated several businesses during his lifetime. (Author's collection.)

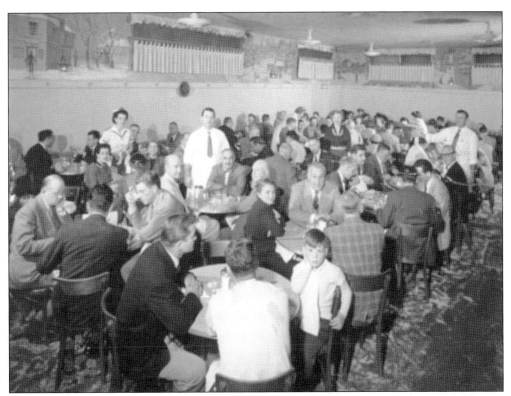

In this 1950s photograph of Little Joe's Restaurant, owner John Nuccio appears in the background. For years, Little Joe's was located in the heart of the Italian community on Broadway across from Chinatown. The family business blossomed from a market that was started in 1898 by Albert Viotto. The landmark restaurant closed in the late 1990s. (Courtesy Nuccio family.)

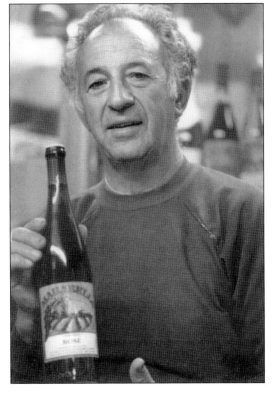

Tony Marabella, the owner/founder of Marabella, proudly holds his newly established label. In 1983, the Marabella Vineyard Company obtained its license to sell wine, a turning point for the small local business where one can still find the old Italian favorites. (Courtesy Marabella Vineyard Company.)

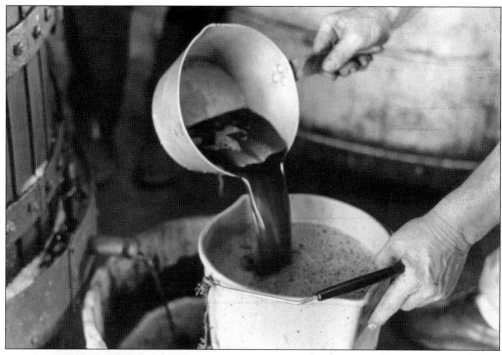

In this c. 1946 image, winemaker Tony Marabella pours the morning juice from the wine press into another container after the grapes have been squeezed. (Courtesy Marabella Vineyard Company.)

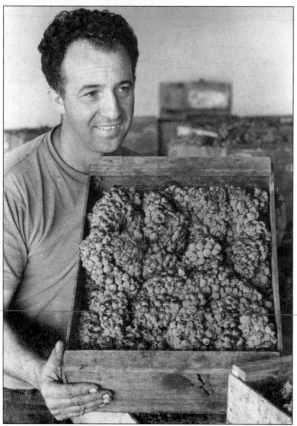

Every morning, grapes are picked from the vineyards 65 miles away in Cucamonga, California. The fresh grapes are then delivered to Marabella's San Pedro facility each afternoon. Nearly 80 tons of grapes are grown each year specifically for the winery's customers. Over the years, tonnage has decreased due to economics, old customers passing away, generation changes, and cultural differences. Tony works the vineyards five days a week from February through August. Field workers harvest the grapes seven days a week and deliver them for crushing at the facility in San Pedro. The winery season extends from August through November. (Courtesy Marabella Vineyard Company.)

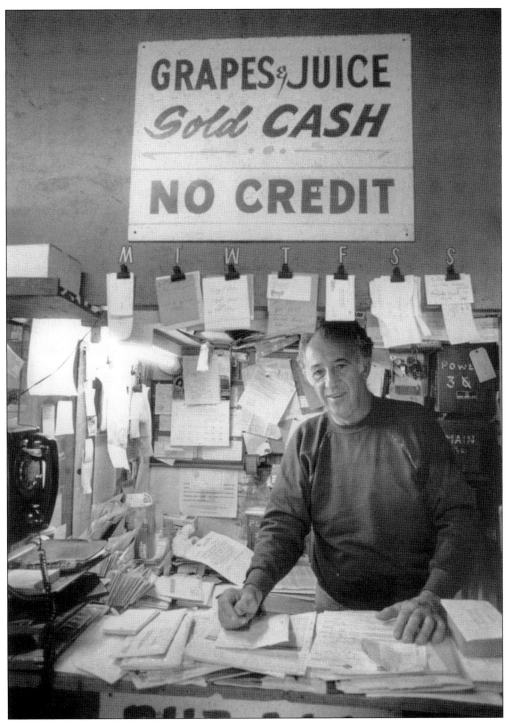

This photograph shows Marabella's filing system. The orders or invoices were placed on a letter corresponding to the day of the week for juice or fresh grape delivery. All sales were cash only because credit was hard to collect in the old days. This company rule still applies today. (Courtesy Marabella Vineyard Company.)

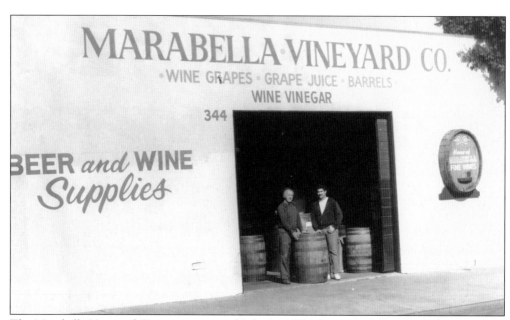

The Marabella Vineyard Company was established in 1932 during Prohibition. Only grapes and grape juice were sold to the public so the people were still able to make wine at home. This was very common throughout San Pedro and Greater Los Angeles. The longevity of the business is due to its owners' honesty, hard work, and family values. (Courtesy Marabella Vineyard Company.)

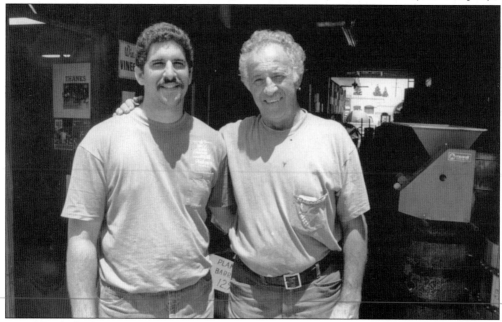

Tony Marabella (right) poses with Steve, the youngest of his three sons. Steve helps the business during winery season when the vineyards are harvested and the grapes are crushed and sold as juice. It is the busiest time of the year. Steve makes the deliveries of grapes and juice to home winemakers. All of the family members have helped in the business throughout the years. One can still find Tony's wife, Theresa Marabella, in the kitchen cooking authentic Italian meals for family and friends. (Courtesy Marabella Vineyard Company.)

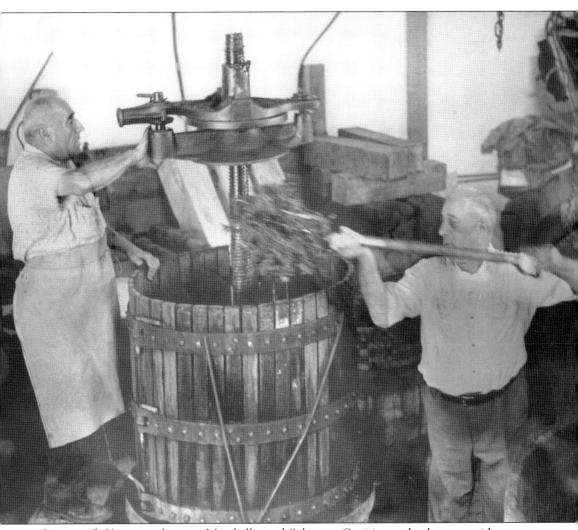

Guiseppi (left), an employee at Marabella, and Salvatore Cenitiempo load a press with grapes. The press holds approximately 2,000 pounds of grapes, which will produce 150 gallons of juice. This process is repeated several times a day to extract the most juice possible. (Courtesy Marabella Vineyard Company.)

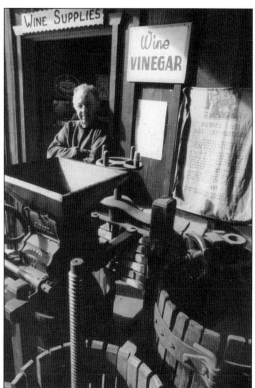

Tony Marabella stands in the doorway of the store. In front of him are antique wine presses and a crusher built in the mid-1930s. These old-timers can still be purchased for squeezing grapes at home or just as collector's items. (Courtesy Marabella Vineyard Company.)

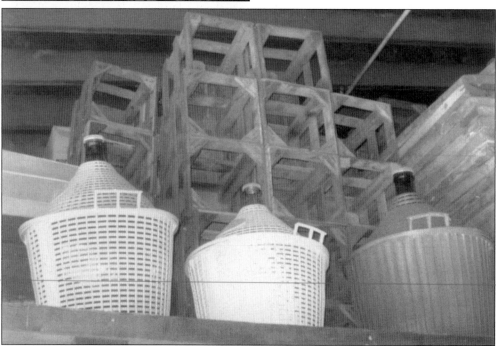

These crates were used to store very old five-gallon glass Sparkletts bottles on their sides for ease of stacking. The bottles seen here are actually 14-gallon jugs from Italy. The weaving on the outside keeps the wine dark for better aging. (Courtesy Marabella Vineyard Company.)

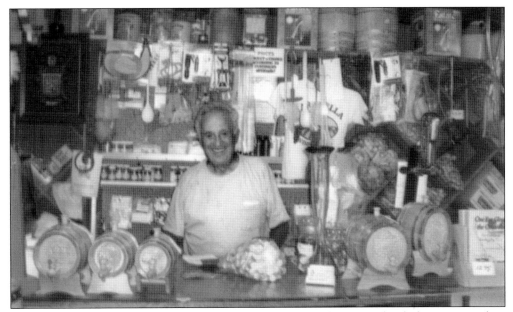

The Marabella Vineyard Company continues to provide beer and wine supplies for home winemakers and home brewers, including corks, barrels, and chemicals. The store also sells recipe books, antique items, wine vinegar, and wine. The owners like to share stories with customers about the old days. For generations, Marabella has earned a reputation for delivering grapes and grape juice to home winemakers. In recent years, the company has distributed wine to stores and restaurants and added a Web site: www.marabellavineyard.com. (Courtesy Marabella Vineyard Company.)

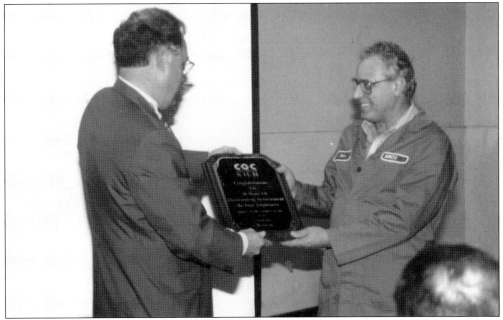

After working for the Arco Oil Company in Wilmington for 30 years, Stefano Finazzo retired from his job as director of the chemical laboratory. Here an unidentified man presents Stefano with an award recognizing his service and dedication. Since his retirement, Stefano has continued his work for the enrichment of the Italian American community. (Courtesy Stefano Finazzo.)

Stefano Finazzo was born in Trappeto (Palermo), Sicily, and attended the Technical Agrarian Institute of Marsala, where he completed an education in agricultural sciences. After visiting relatives in Southern California, in 1962 Stefano was urged by his uncle to move to the United States. He decided to make his home in San Pedro and obtained employment at the Atlantic Richfield Company. (Courtesy Stefano Finazzo.)

Four

FAMILY

A tavola non si invecchia.
At the table with good friends and family, you do not become old.

Perhaps the most important quality of Italian Americans was their strong families and extended families built with paesani who also emigrated from Italy. In the late 19th and early 20th centuries, many Italians left their country in hopes of finding more opportunities in America. The early Italians who chose to live in Los Angeles contributed to the economic prosperity of the growing city. The European culture blended with the Hispanic heritage found in California. Italians in Los Angeles did not live in segregated areas but had the freedom to construct their homes anywhere in the city. Many of the first immigrants built thriving businesses with the intention of passing the enterprises on to the generations that followed. After World War II, second- and third-generation Italian Americans came to Los Angeles in record numbers. The culture began to intermingle with the American lifestyle. Since the 1980s, there has been a resurgence of passion in preserving and celebrating the Italian culture for future generations.

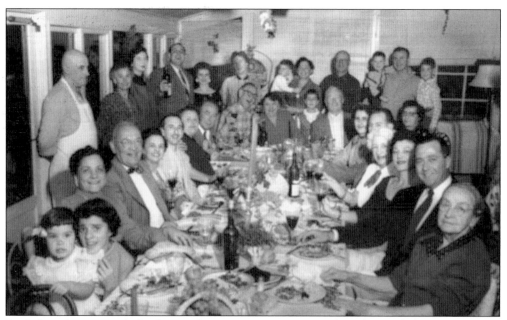

For Italian Americans, *la familia* was the main component. Family and extended family members gathered to celebrate holidays and special occasions. This photograph shows Thanksgiving at John Gadeschi's home in 1954. Steve Nuccio is the boy in the right background. (Courtesy Nuccio family.)

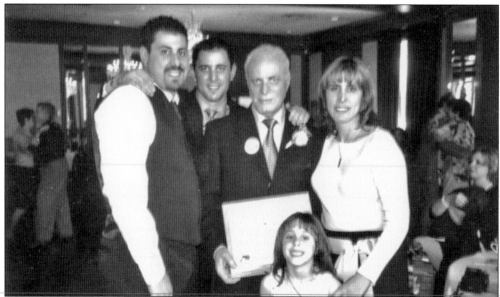

A few years ago, Federated Italo-Americans of Southern California named Stefano Finazzo as Man of the Year. Since his arrival from Italy in 1962, he has worked to assist the Italian Americans throughout Greater Los Angeles. He is currently working along with Silvano Mizrahi to establish La Piazza Italian Cultural Center. Proud of his heritage, Stefano has commented, "Deny the blood that runs through your veins and you disappoint the Italian community. Don't ever forget your roots, the main reason we came to America." Pictured are, from left to right, Giuseppe, Sal, Stefano, Josephine, and granddaughter Stephanie. (Courtesy Stefano Finazzo.)

Filippa Colombo settled in Los Angeles with her husband, Salvatore "Sam." In the early 1950s, when her son Peter was in the service, Filippa traveled to Italy for a reunion with Peter (center) and other relatives still living there. (Courtesy Mary Colombo Schulz.)

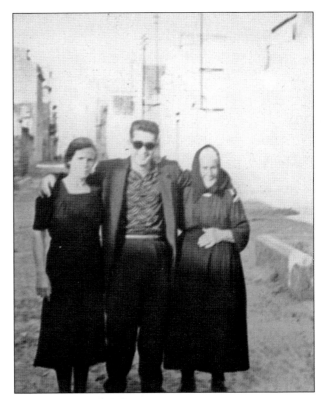

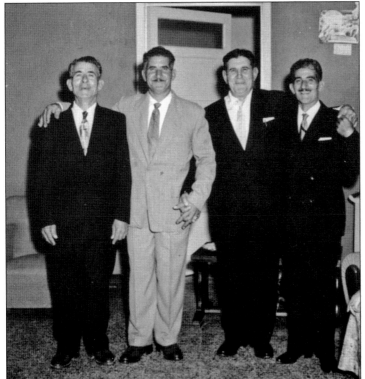

The four Colombo brothers grew up as children in Sicily. Two immigrated to the United States, ending up in Los Angeles, and the other two to Venezuela. This reunion photograph from the early 1960s is rare because the brothers only reunited twice after their transcontinental migration. Pictured from left to right are Sam, Marco, Vito, and Nino Colombo. (Courtesy Mary Colombo Schulz.)

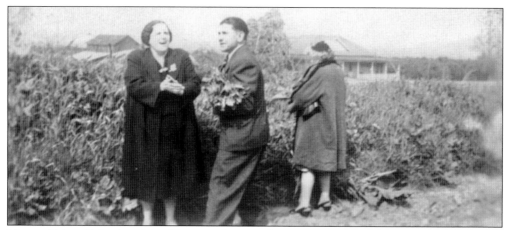

Vito and Mary Colombo pick wild mustard greens during an outing in 1947. Marie Schulz (right) looks over the field. The greens grew in abundance after the spring rains. They were picked freely in open fields because many people considered them to be weeds. The trunk would be lined with newspapers and then piled high with the picked greens. Upon returning home, the ladies would clean, wash, boil, and finally sauté the mustard greens in olive oil. (Courtesy Mary Colombo Schulz.)

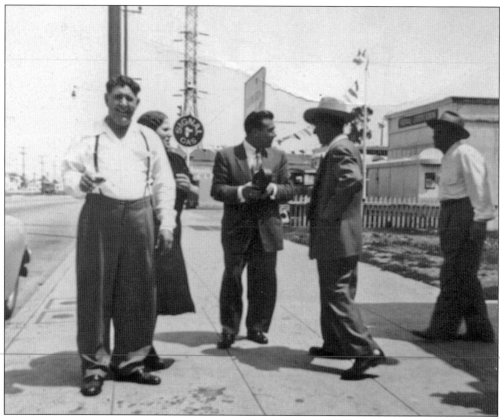

Vito Colombo toasts the camera saying, "*A la salute!*" Others are headed toward the car parked at the curb. Behind Vito are, from left to right, his wife, Mary; an unidentified friend; Sam Colombo; and Frank Salerno. (Courtesy Mary Colombo Schulz.)

50

"Signore Nino," as he was called, was a widower who had emigrated years earlier from Italy. He lived alone and did not read or write English. Nino had one son who lived in South America, and Mary Colombo would help the two correspond. (Courtesy Mary Colombo Schulz.)

Sophia Luccia Durzo, shown here in the early 1950s, was born in Calabria, Italy, in 1886. The Scott family of Pennsylvania adopted her without legal papers. Years later Sophia was reunited briefly with her blood sister, also adopted, who was then living in Wisconsin. Her daughter Mary Durzo Colombo settled in Los Angeles, and Sophia frequently visited. (Courtesy Mary Colombo Schulz.)

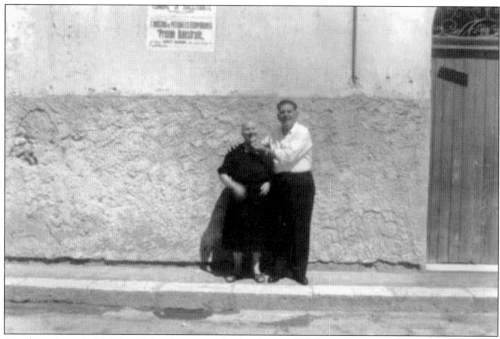

On this trip to Italy, Vito Colombo enjoyed a final visit with his mother before her death. Often when Italians moved to start a new life in the United States they had to abandon family members. Vito contributed to his mother's financial support by sending funds to her on a regular basis. (Courtesy Mary Colombo Schulz.)

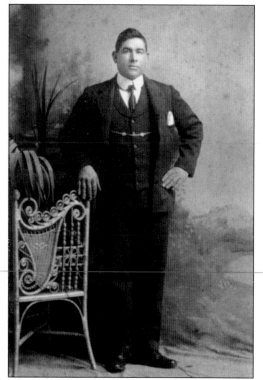

Pietro Colombo died around 1910. Together with Maria, he had two daughters and four sons. Pietro was a hardworking man of honor; however, little else is known. (Courtesy Mary Colombo Schulz.)

Vito Colombo immigrated to the United States in 1909, leaving his mother, Maria, and two sisters in Italy. He was reunited with his mother only twice between 1909 and her death. This photograph was taken in 1948, when Maria flew to Los Angeles for a brief visit. (Courtesy Mary Colombo Schulz.)

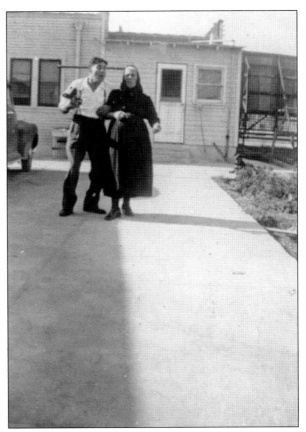

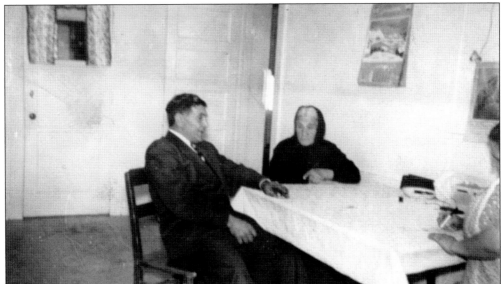

"Matra Maria," as she was known, was the epitome of the stern matriarch. Here she discusses family matters with her son Vito in Los Angeles in the late 1940s. Maria Garlofalo Colombo was in her late 70s, and despite her small stature, her spunky character and sharp tongue lived long after her death. (Courtesy Mary Colombo Schulz.)

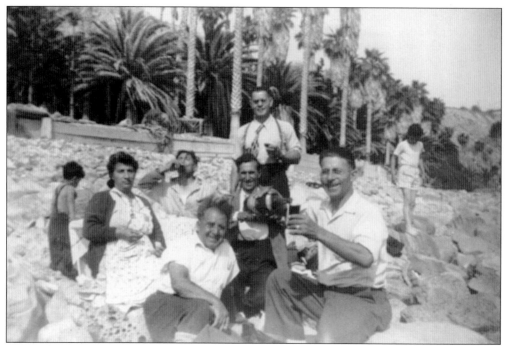

For many Sicilians living in Southern California in the late 1940s, it was not unusual to pack some fresh bread, cheese, and other treats for a picnic; of course, homemade wine was usually included. Sam Colombo (right) toasts in the company of fellow *paesani*. (Courtesy Mary Colombo Schulz.)

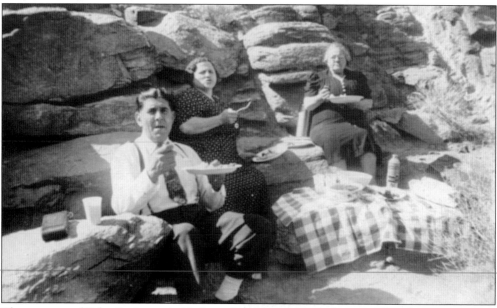

The canyons of Palm Springs provided another favorite picnic location. People went out for a long day's journey for a picnic, driving over 100 miles. The men typically wore shirts and ties, and the women donned nice dresses and packed tablecloths, dishes, and silverware. Vito Colombo (left); his wife, Mary (center); and Mary's mother, Sophia Durzo, are seen in this photograph. (Courtesy Mary Colombo Schulz.)

Mary Colombo is a second-generation Italian. When her parents moved from Detroit to Los Angeles in 1943, she moved with them, even though she held a good job working for the union at Ford Motor Company. After arriving in California, she worked in the Italian market and café that her father had established. In the early 1950s, she had the opportunity to work for the Atlantic Richfield Company as a bookkeeper. She retired from the company after being employed for over 30 years. (Author's collection.)

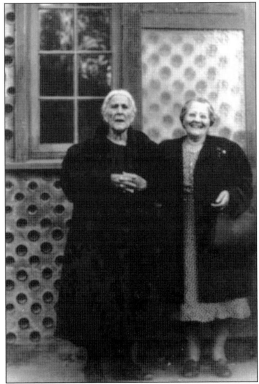

Two mothers-in-law met in Southern California for the first time in 1948: Matra Maria (left) and Sophia Durzo. Since Maria lived in Italy and Sophia in Pennsylvania, this was the only time they would see each other in person. (Author's collection.)

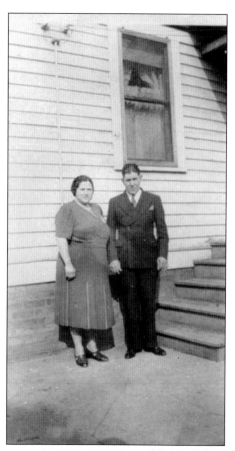

Vito and Mary Colombo married in 1919, when Vito was 24 and Mary was 18. Vito arrived in the United States around 1910 and served in World War I. The couple gradually moved across the country, living in Pittsburgh, Pennsylvania, and Detroit, Michigan, before settling in Los Angeles. Vito also worked in the coal mines in Utah for a brief period of time. (Courtesy Mary Colombo Schulz.)

This typical Sunday spaghetti dinner at the home of Vito and Mary Colombo shows, from left to right, the back of Clifford Schulz's head (husband to Mary Colombo Schulz), Joe Garofalo, Agatha Garofalo, Vito Colombo, Rose Durzo Colombo, and Mary Durzo Colombo. (Courtesy Mary Colombo Schulz.)

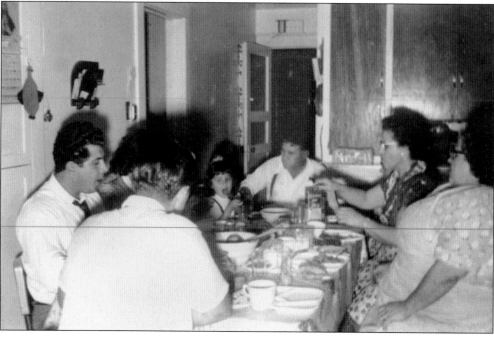

Mary Colombo is dressed as a bridesmaid for a wedding around 1946. This photograph was taken outside her parents' Silver Dollar Café, located on Century Boulevard in Los Angeles. (Author's collection.)

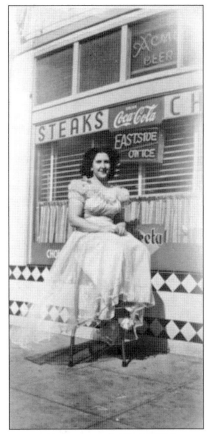

Sam Colombo shows off his garden to his brother and sister-in-law, who were visiting Los Angeles from their home in Venezuela. This photograph was taken in the early 1960s. (Courtesy Mary Colombo Schulz.)

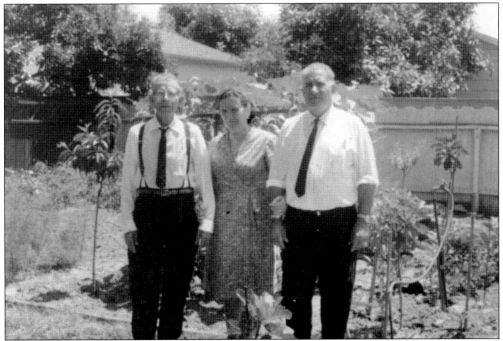

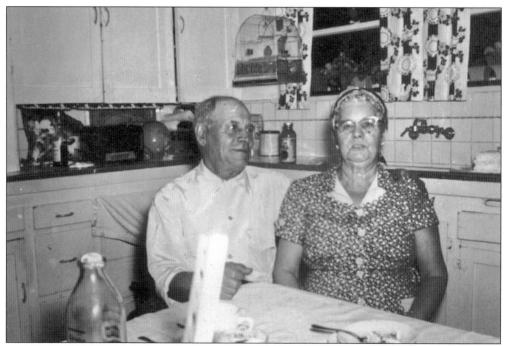

Frank Salerno and Concetta immigrated to Los Angeles from Sicily. With no family in the area, they became part of Vito and Mary Colombo's extended family. The two couples were not related by blood but instead by the hardships and successes that they had endured. Close kinship with *paesani* was typical in the warm Italian household. (Courtesy Mary Colombo Schulz.)

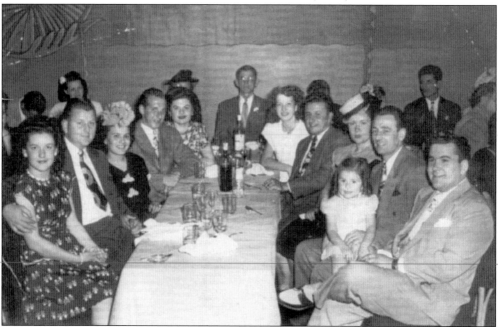

A family dinner is held in a large rented hall in Lincoln Heights about 1948. Although not specifically identified, all people dining include parents, aunts, uncles, and grandparents of J. B. Griffin, publisher of *So Cal Italian Magazine*. (Courtesy J. B. Griffin.)

For many years, the core of the Italian neighborhood was adjacent to Chinatown on Broadway. This photograph of the Alessandro family was taken in 1952, long after the historic neighborhood had faded away. Here grandmother Geraphina (left), Richard (center), and mother Elizabeth enjoy a weekend visit in Chinatown. (Courtesy Alessandro family.)

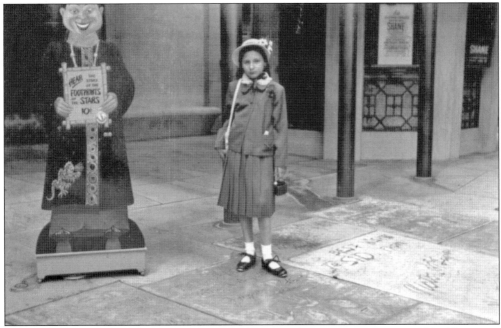

Carole Alessandro poses at Grauman's Chinese Theatre on May 31, 1953. (Courtesy Alessandro family.)

Forest Lawn Memorial Park was a favorite spot for the Alessandro family to go for weekend outings. The family went to the cemetery not just for funerals or to visit graves but also to enjoy the grounds, the swans in the lake, the picnic area, and celebrity graves. (Courtesy Alessandro family.)

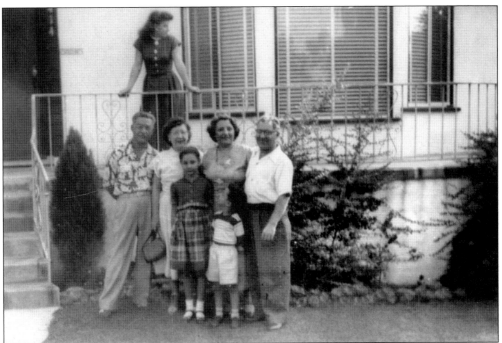

Alessandro family members gather outside their home in Glendale in September 1952. Pictured here are, from left to right, (first row) Carole and Richard Alessandro; (second row) unidentified couple, Elizabeth Alessandro, and her husband, Basil; (third row) unidentified. (Courtesy Alessandro family.)

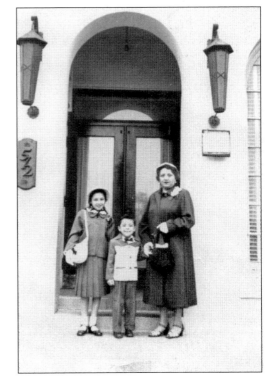

Carole Alessandro Melone (left), Richard Alessandro (center), and Elizabeth Alessandro stand in front of the Normandy Apartments, where the family was living, on Easter Sunday in 1952. (Courtesy Alessandro family.)

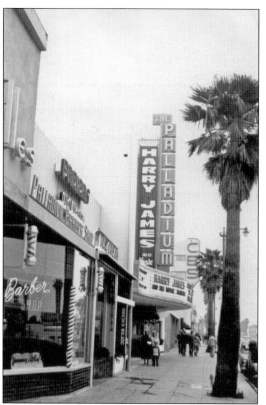

Easter Sunday was a time to get dressed up and enjoy a family outing. In this photograph, Alessandro family members pose near the theater marquee announcing Harry James at the Hollywood Palladium. Three generations are represented here (from left to right): mother Elizabeth, grandmother Geraphina, and son and grandson Richard Alessandro. (Courtesy Alessandro family.)

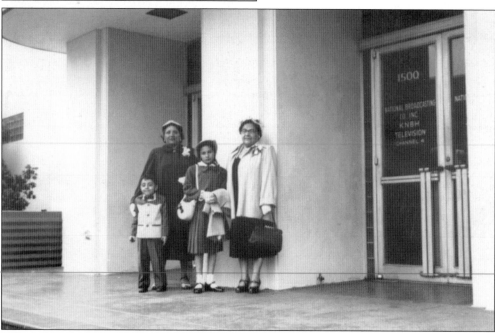

When the Alessandro family toured NBC, they also took the time to explore the studios of CBS. At the time this photograph was taken in 1953, both studios were located a short distance from each other on Sunset Boulevard. (Courtesy Alessandro family.)

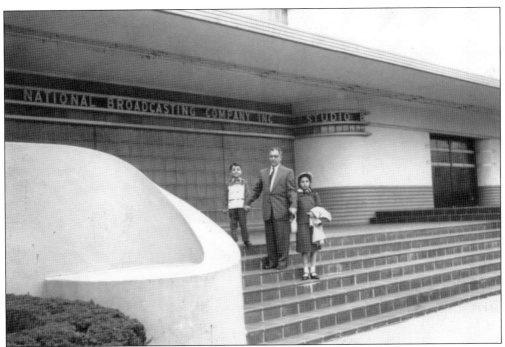

In April 1953, the Alessandro family had the opportunity to attend the taping of a television show. Going up the steps to enter the NBC studios is Basil Alessandro (center), along with his son Richard and his daughter Carole. (Courtesy Alessandro family.)

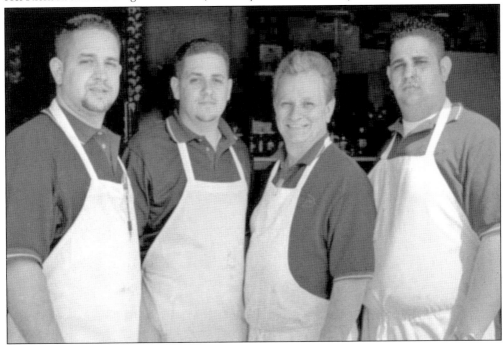

Members of the Angiuli family work together to run the successful Eastside Market and Italian Deli on Alpine Street in Los Angeles. The deli has been a cultural landmark eatery since the early 1970s. (Courtesy Angiuli family.)

Stefano Finazzo moved from his native Trappeto, Sicily, in 1962. Shortly after moving to the United States, he met Gemma Vaccaro. The couple married in 1968 and had a large Italian wedding with close to 500 guests in attendance. (Courtesy Stefano Finazzo.)

Holiday celebrations at the Finazzo home attracted many people, from immediate to extended family members. The couple typically had 30 to 40 people in their house for Christmas dinner. (Courtesy Stefano Finazzo.)

Before Gemma's passing, Stefano and his lovely wife enjoyed the opportunity to go out in the community and attend events held by St. Mary Star of the Sea Church in San Pedro or activities at many of the organizations where the couple actively participated. The Finazzo family fondly remembers Gemma. (Courtesy Stefano Finazzo.)

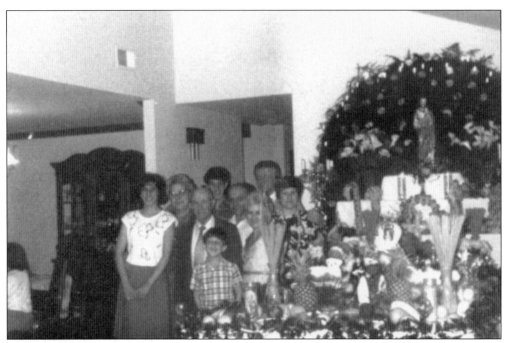

Celebrating St. Joseph Day on March 19 is a tradition in the Finazzo family. The altar is arranged with a statue of St. Joseph, fruits, and breads. Food on the table is given to local charities. (Courtesy Stefano Finazzo.)

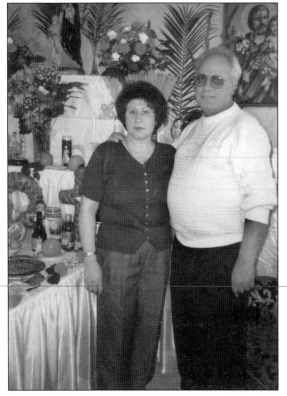

Stefano and Gemma Finazzo stand next to the large decorated St. Joseph altar at the traditional St. Joseph gathering held in their San Pedro home. For several decades, the celebration of the feast has been popular with Sicilians who immigrated to the United States. In keeping with the tradition, a person "gives" a St. Joseph table in thanksgiving for a prayer request that has been received, such as the safe return home of a relative serving in the military or the maintaining of good health. (Courtesy Stefano Finazzo.)

In the 1970s, Giuseppe Finazzo (second from left) volunteered at the elementary school in San Pedro, where he shared his love of gardening with his grandchildren and their unidentified classmates. (Courtesy Stefano Finazzo.)

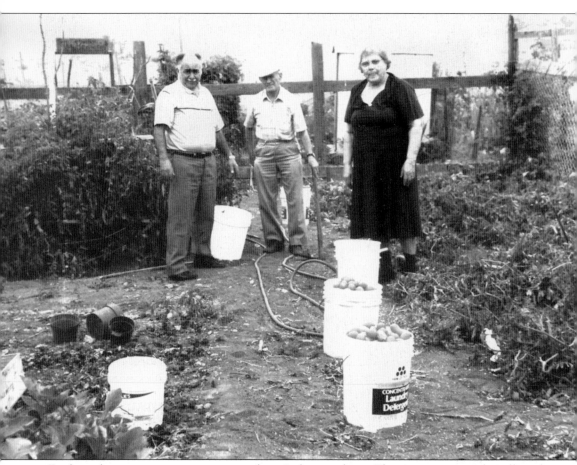

Fresh garden-grown tomatoes are a staple in Italian cooking. The community garden allowed large quantities to be grown, similar to how tomatoes were cultivated in Sicily. Giuseppe and Giuseppa Finazzo and Antonio Finazzo, visiting from Brazil, harvest buckets of tomatoes in this 1970s photograph. (Courtesy Stefano Finazzo.)

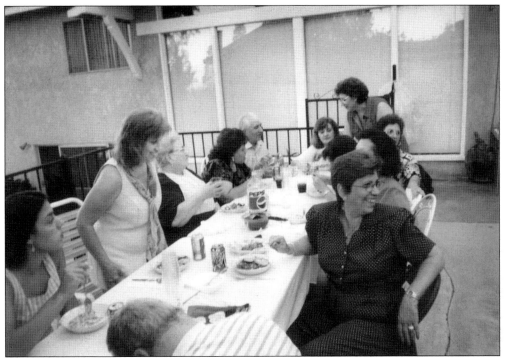

Guests watch others at a pasta party eating pasta off a wooden board. This has been a Sicilian custom used for special events. (Courtesy Stefano Finazzo.)

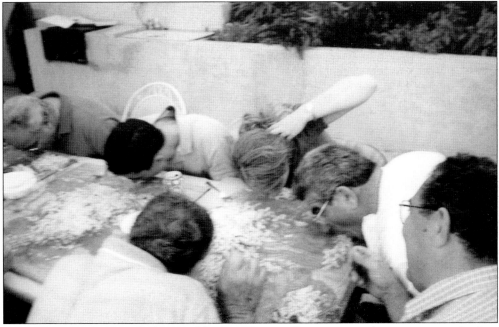

A pasta party is held at the home of Stefano Finazzo. Eating pasta *a la scanatura* is a Sicilian custom used for special events. The pasta is homemade on the *maida*, or wooden board. The board is cleaned and the pasta cooked and then piled back on the board, from which everyone enjoys the meal without plates or utensils. (Courtesy Stefano Finazzo.)

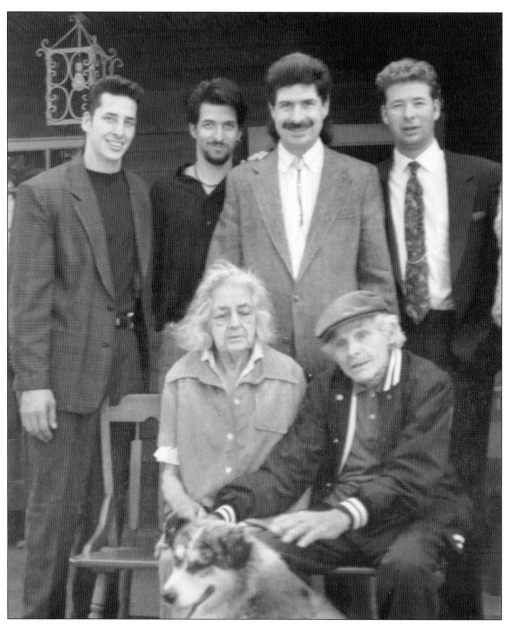

The Politi family joins to celebrate the honor Leo received in having a Los Angeles elementary school named in his honor. Pictured here, from left to right, are the following: (first row) family dog Corky, Helen, and Leo; (second row) Mitch, Martin, Paul, and Mike. (Courtesy Leo Politi family. All Rights Reserved.)

Five

FAITH AND DEVOTION

Senza Dio nulla vale.
Without God all indeed is in vain.

The vast majority of Italians who immigrated to Los Angeles were baptized Catholic either in Italy or after they came to America. For many, their faith reinforced their culture and provided an opportunity to socialize with people who shared the same beliefs. Italians brought with them traditions and folk practices that included setting aside particular days to remember regional saints that were honored in Italy. Popular saints included St. Rocco, the patron saint of Potenza; San Gennaro, popular with the people from Naples; and St. Anthony of Padua and St. Joseph, who were both popular with those who traveled from Sicily. For Italians, the language used for worship at the Mass each Sunday was Latin, which was somewhat similar to their native Italian language. The Spanish, Irish, and French who settled in the same regions did not appreciate many of the religious traditions that the Italians brought with them.

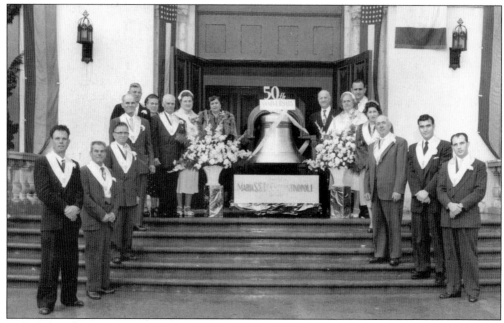

A faith-based religious community is a point of reference for many of the Italians who came to America, particularly for those who settled in California. The early settlers came from northern Italy and were soon followed by those from southern Italy until all of the major regions were represented. The Italians who emigrated brought with them a strong faith rooted in Roman Catholicism and diverse regional traditions. Here unidentified parish members dedicate a new church bell to commemorate St. Peter's Italian Church's 50th anniversary in 1955. (Courtesy St. Peter's Italian Church.)

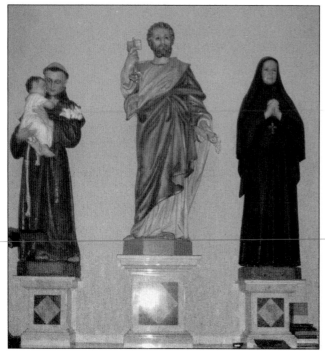

Numerous statues inhabit the interior of St. Peter's Italian Church. The tradition of commemorating the virtues of saints with their feast days was brought to the United States from Italy. Different geographical regions identify more closely with particular saints. Pictured here are St. Anthony of Padua (left), St. Joseph (center), and St. Francis Carbrini. (Courtesy St. Peter's Italian Church.)

St. Therese (1873–1897) was born in Normandy, France, and lived as a Cloister Carmelite nun for 10 years. She was known for having total trust in the Lord and doing ordinary things in extraordinary ways. Her life was inspirational to many immigrants. Her statue can be found inside St. Peter's Church. (Courtesy St. Peter's Italian Church.)

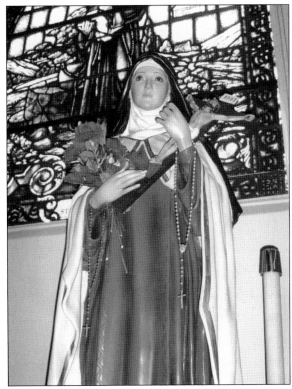

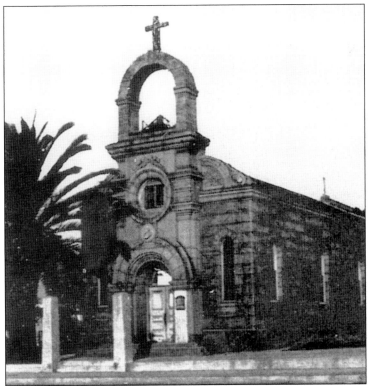

In 1904, St Peter's Italian Church began as a mission church for the spiritual needs of the Italian people of Los Angeles. During the early years of the church, Little Italy stretched from the wineries in downtown Los Angeles where Olvera Street is now located to the area that is now Chinatown. When St. Peter's was established, it was situated in the center of the Italian community. (Courtesy St. Peter's Italian Church.)

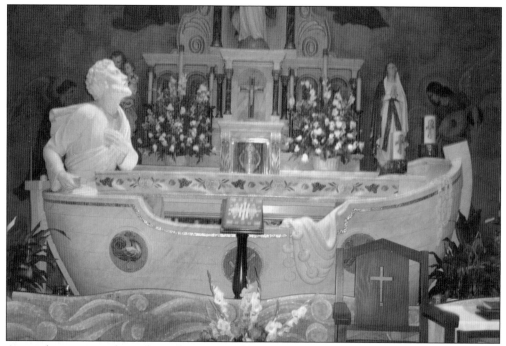

As parishioners moved into the outlying areas of Greater Los Angeles, they continued to consider St. Peter's their special place of worship and celebration. The church's marble altar, seen here, is shaped like a boat with a larger-than-life image of St. Peter. (Courtesy St. Peter's Italian Church.)

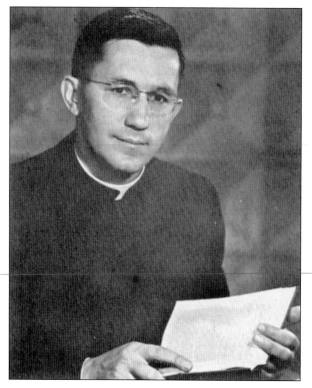

Italians who settled in Los Angeles came from Piemonte in the north, Tuscany, Ischia in Campania, Bari in Puglia, and various provinces in Sicily. As the Little Italy community dissipated in the 1930s and early 1940s as a result of the wineries closing, the Depression, and a move to the suburbs, Fr. Michael Cecere envisioned a new larger church that would reunite the Italian community for a common cause. Father Cecere, who was born in Puglia and immigrated to the United States as a child, remained at the church from 1943 until 1947. (Courtesy St. Peter's Italian Church.)

The need to build a new church for St. Peter's Italian community became essential when the old chapel was destroyed by fire. The cornerstone for the church was laid on April 13, 1947. (Courtesy St. Peter's Italian Church.)

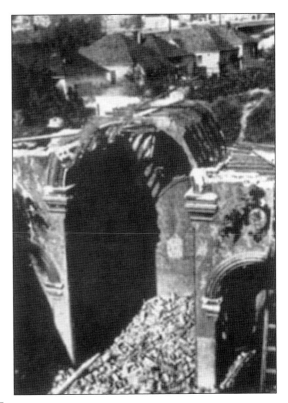

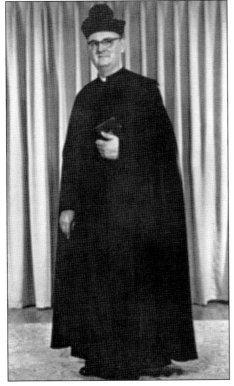

Succeeding Father Cecere, priests from the Claretian order served the community. In 1954, the Archdiocese of Los Angeles again managed the parish. Fr. William Salvatore Vita, a dynamic priest from the diocese, was named pastor. He managed to create a nearby rectory for priests, encourage the archbishop of Los Angeles to recognize St. Peter's as a full parish in addition to a parish for all Italians of the archdiocese, eliminate the church's construction debt, and build a meeting hall for large gatherings. (Courtesy St. Peter's Italian Church.)

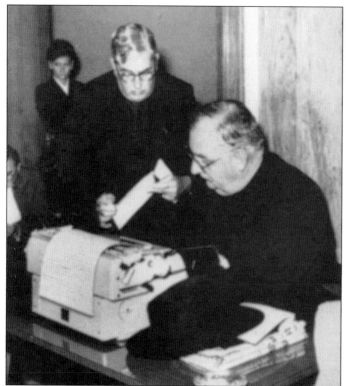

After his assignment at St. Peter's, Father Vita was named pastor of St. Michael's Church in South Central Los Angeles. While assigned there, he was called to Rome as a priest liaison for the second Vatican council, a job that was a natural fit for this former newspaper journalist. (Author's collection.)

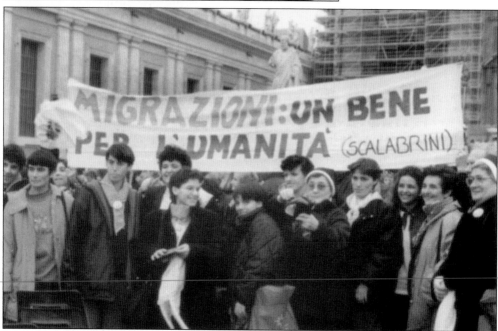

For a brief period of time in the 1960s, a rumor spread that St. Peter's Italian Church would be altered to meet the needs of the growing Hispanic and Chinese immigrants settling in the area. A protest was held by a group of mainly Pugliesi, who publicly displayed their desire to keep St. Peter's an ethnic Italian church. (Courtesy St. Peter's Italian Church.)

Cardinal McIntyre, then the ecclesiastical head of the Catholic Church in the Archdiocese of Los Angeles, recruited the Scalabrini Fathers to manage St. Peter's Italian Church in the early 1960s. The fathers also assisted in serving the growing Italian American community that continued to move many miles away from St. Peter's. (Courtesy St. Peter's Italian Church.)

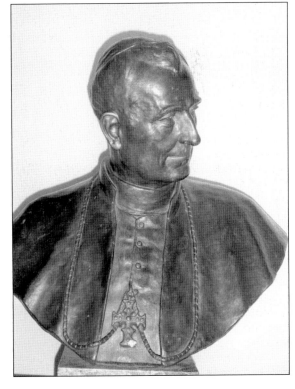

The religious order Missionaries of St. Charles Borromeo—more commonly known as the Scalabrini Fathers—was founded by John Baptist Scalabrini, bishop of Piacenza, Italy, in 1905. Its main goal was to provide for the needs of the Italian immigrants to America. When the order arrived in New York, the fathers established parishes to provide for the spiritual needs of the Italians and services to assist those needing food and shelter. The news of the good works spread across the country and world, and by 1910, the order was operating 21 parish churches and also providing service in Canada and Brazil. A statue of the order's founder stands in the vestibule of St. Peter's Church. (Courtesy St. Peter's Italian Church.)

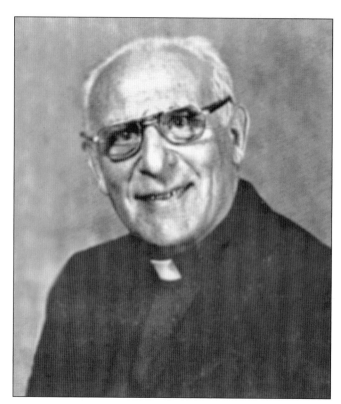

Respected and loved, Fr. Luigi Donanzan of the Scalabrini order was an energetic pastor who was able to revitalize the Italian community and bring growth and expansion. He started an advertising campaign to bring Italian Americans back to St. Peter's by fostering Italian culture and traditions. He raised awareness and funds for the rebuilding of the Casa Italiana Hall into a large modern facility suitable for banquets, weddings, and celebrations. (Courtesy St. Peter's Italian Church.)

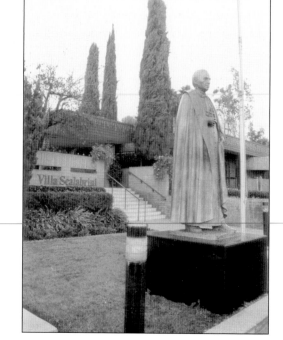

Father Donanzan also embarked on a successful fund-raising campaign to build a retirement community for Italian Catholics in their senior years. The Villa Scalabrini retirement center in Sun Valley was dedicated in 1979. (Courtesy St. Peter's Italian Church.)

Los Angeles, California, 19 ___ of Decemb. A.D. 1904. On this day the Rev. Father _Titus Piacentini_ ___ solemnly baptized _Isabella_ ___ born on the ~~A~~ fifth of December A.D. 1904. Son ~~daughter~~ of ~~Stefano~~ _Giangregorio Giovacchino_ ___ and ~~Maria Vittoria~~ _Rocchetta Palardino_ ___ The sponsors were _Giovanni Sizri & Maria Tiana Sizri_ ___

1905

In witness I sign _Piacentini_ ─── Rector

───────────────

Los Angeles, California, _eighth_ of _January_ A.D. 1905. On this day the Rev. Father _Titus Piacentini_ ___ solemnly baptized _Giuseppe_ ___ born on the _25_ of _September_ A.D. 1904. ~~Son~~ Daughter of _Pietro Silano_ ___ and ~~Carmela Silano~~ ___ the sponsors were _Giuseppe Frisengo, Margherita Solcinale, Catherine Brown_ ___

In witness I sign, _Piacentini_ ___ Rector

───────────────

Lso Angeles, California, _eighth_ of _January_ A.D. 1905. On this day the Rev. Father _Titus Piacentini_ ___ solemnly baptized _Alfredo_ ___ born on the _10th_ of _July_ A.D. 1901. Son Daughter of _Pietro Silano_ ___ and _Carmela Silano_ ___ the sponsors were _Giuseppe Frisengo, Margherita Solcinale_ ___

In witness I sign, _Piacentini_ ___ Rector

───────────────

Los Angeles, California, _15_ of _January_ A.D. 1905. On this day the Rev. Father _Titus Piacentini_ solemnly baptized _Giovanni_ ___ born on the _13_ of _August_ A.D. 1904. Son Daughter of _Paolo Aloi_ ___ and _Letizia Palermo_ ___ the sponsors were _John P. Arghitis and Francesca Garofalo_ ___

In witness I sign. _Piacentini_ ___ Rector

───────────────

Los Angeles, California, _15_ of _January_ A.D. 1905. on this day the Rev. Father _Titus Piacentini_ ___ solemnly baptized _Pasquale_ ___ born on the _20th (20th P)_ of _August_ A.D. 1904. Son Daughter of _Pasquale Lasalvia_ ___ and _Maria Lasalvia_ ___ the sponsors were _Luigi Gaudio & Agnese Gaudio_ ___

In witness I sign. _Piacentini_ ___ Rector

The sacraments of baptism, first Holy Communion, confirmation, and marriage are as important in the current day as they were in the early 20th century. Seen here is a page from the 1905 baptism register at St. Peter's. (Courtesy St. Peter's Italian Church.)

First Communion services were important religious occasions typically occurring in the spring. The day, marked with joy and anticipation, required one to two years of religious education before the child was ready to receive the sacrament. This photograph from the early 1930s shows the typical attire worn by girls upon the occasion of their first Communion. (Author's collection.)

An unidentified young girl assumes a religious pose in front of her Los Angeles home before going to church to receive her first communion in the 1950s. (Author's collection.)

Two unidentified boys, pictured around 1920, are dressed in clothing related to First Communion or confirmation. During the sacrament of confirmation, children are anointed with blessed oils by the bishop. The youth declare their faith and accept the responsibility to practice and live with good morals and virtues. Confirmation brings the youth more fully into the life of the church. (Author's collection.)

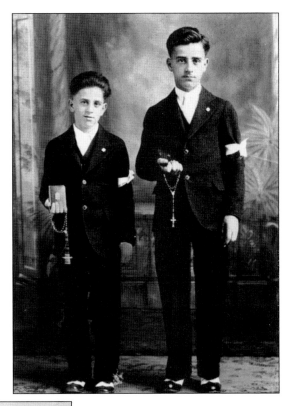

Weddings were times of joy and celebration, and St. Peter's was the center of such occasions. A page from the 1904 marriage register is seen here. (Courtesy St. Peter's Italian Church.)

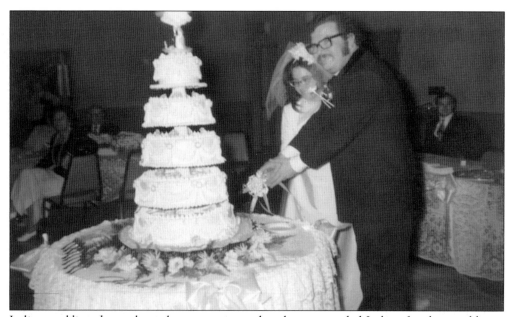

Italian weddings have always been occasions when large extended Italian families could join with distant relatives, friends, and neighbors in celebration. It was not unusual for the parents of the wedding couple to invite several hundred family members, extended family, and friends. (Author's collection.)

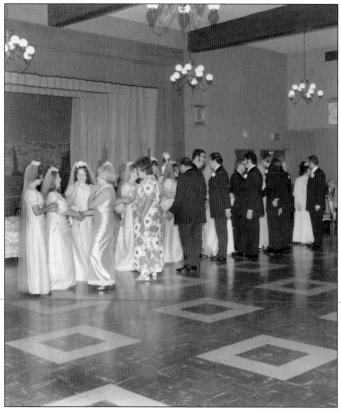

In this photograph from the early 1970s, the wedding party is lined up to greet guests. Traditionally the first people to walk through the receiving line were members of the party, who then also took their place standing in line with the bride and groom. The reception for this wedding was held at Casa Italiana the first year that the hall opened. (Author's collection.)

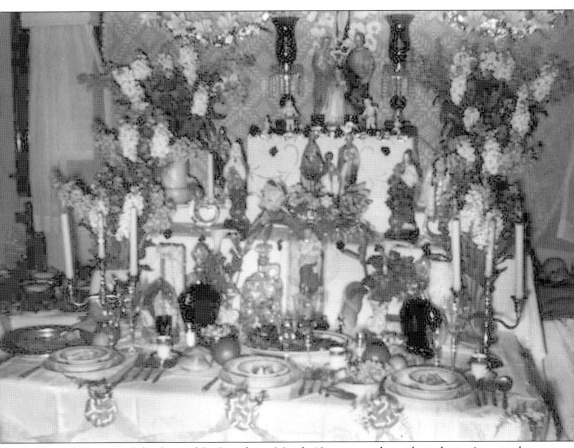

The celebration of the feast of St. Joseph on March 19 was a tradition brought to America by Italians who emigrated from Sicily. The feast was always held in the middle of Lent, providing people with an opportunity for sacrifice and giving to the poor. The devotion to St. Joseph, the earthly father of Jesus, was based on a cultural folk religious devotion as a form of thanksgiving for answered prayers. Typically St. Joseph tables were given when a loved one returned safely from war or for personal devotion, the curing of an illness, good fortune, and thanksgiving. Three plates are set in honor of Jesus, Mary, and St. Joseph. (Courtesy Mary Colombo Schulz.)

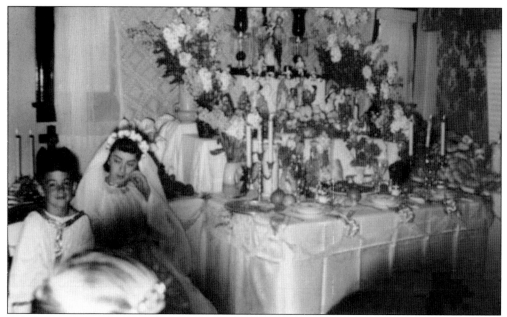

An altar is set in a home or hall with candles, statues, and an abundance of breads, pasta, fish, and meatless dishes. Everything on the altar has a deep symbolic meaning. A priest opens the celebration by blessing the food, and then amateur actors reenact the Holy family's search for lodging, with the actors eating first and the throngs of attendants second. Friends and family members who are invited to attend a St. Joseph table are obligated to attend. Both food and money are donated for the poor and homeless in the community. (Courtesy Mary Colombo Schulz.)

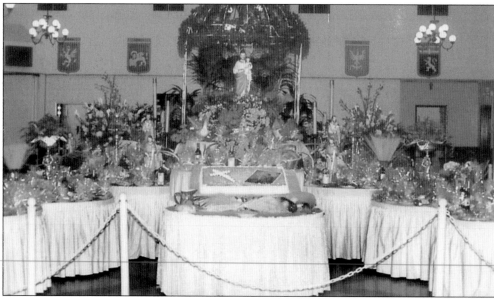

Each guest who attends a St. Joseph table is given a fava bean (*vicia fava*) to take home with them as a symbol of luck. Tradition states that as long as a person has a fava bean to carry with him, he will never go broke or be without food. This sentiment derived from a famine in Sicily when the only food available was the fava bean, which prior to the famine had been used to feed livestock. (Courtesy St. Peter's Italian Church.)

Six

ORGANIZATIONS

Italians living in America have strong regional ties to the area of Italy where they or their ancestors were born. When two Italians meet, one of the first questions usually asked is "What part of Italy are you from?" Regional ties stretch the oceans and link current generations with the past. It is not surprising that instead of one or two Italian organizations, there are over 70. Many active Italians belong to several different groups that meet in and around Los Angeles. The Italian American organizations pictured in this chapter serve to represent the many others in the city.

The Federated, short for the Federated Italo-Americans of Southern California, was founded in 1947. This organization connects with other Italian organizations both in and outside Los Angeles and serves as an umbrella group. A few more of the key organizations include the National Italian American Foundation (NIAF), which provides advocacy in Washington, D.C.; the order of Sons of Italy in America; UNICO National, which is the largest Italian American service organization in the country; the American Italian Historical Association; and the Italian American One Voice Committee, which combats negative stereotyping. Numerous religious, cultural, and regional organizations meet in and around the city as well.

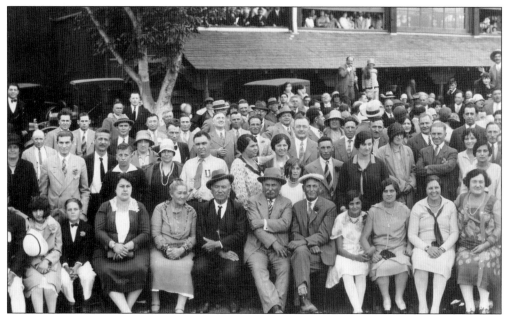

The Italian Mutual Benevolence Society is the oldest organization in Los Angeles. It was established in 1877 by Ambrogio Vignolo and Antonio Pelanconi, two local business owners who had emigrated from Italy. In 1888, la Società Unione e Fratellanza Garibaldina emerged. In 1916, both of these organizations merged under the name of the Garibaldina Society (la Società Garibaldina di Mutua Beneficenza), or the Society of Garibaldina of Mutual Benefit. (Courtesy Garibaldina Society.)

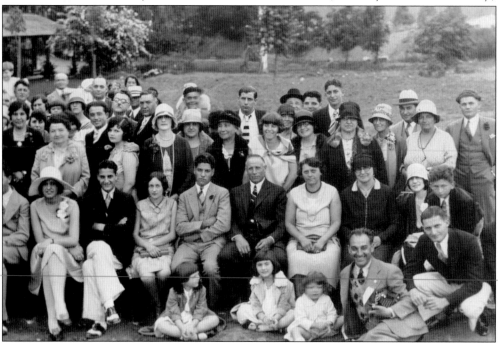

In the early 1900s, the Garibaldina Society met at the Italian Hall on Olvera Street, which was the original home to the Italian community. As people moved to the suburbs and the Italian Hall was closed, a new meeting location was established. (Courtesy Garibaldina Society.)

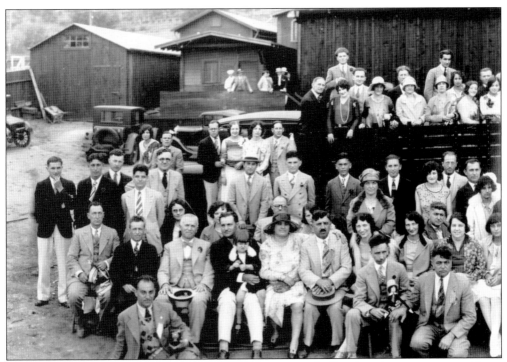

The Garibaldina Society is the oldest Italian association in the Los Angeles area to meet without interruption since being founded. (Courtesy Garibaldina Society.)

The Garibaldina Society meets in this 40-year-old building located in the Highland Park area of Los Angeles. (Courtesy Garibaldina Society.)

The modern facility, which is used by many other Italians organization in the area, includes a large banquet room, a dance floor, and a large professional kitchen. (Courtesy Garibaldina Society.)

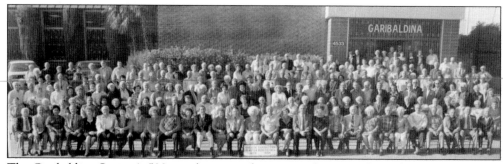

The Garibaldina Society's 500 members provide emotional support for each other in times of illness and loss. (Courtesy Garibaldina Society.)

Italian immigrants of the 19th and 20th centuries brought bocce with them to the United States. The game is played between two teams who take turns throwing a smaller ball called the jack or boccino to the far end of the court. (Author's collection.)

The large indoor bocce court at the Garibaldina Society provides a casual place for people to pass the time in the company of people close in age and with similar ethic backgrounds. Bocce is similar to lawn bowling, with the winning team typically needing to score 13 points. The game requires skill, practice, and patience to roll the ball with sufficient accuracy. Part of the game is the opportunity to meet old friends and socialize. (Courtesy Garibaldina Society.)

Emil Mor, president of the Garibaldina Society, and club officer Katie Giannoni provide leadership and stability to the longtime members of the organization. (Courtesy Garibaldina Society.)

The past anchors Garibaldina members, who feel a sense of unity attending functions at the facility. Katie Giannoni looks at the historic photographs hung in one of the hallways. (Courtesy Garibaldina Society.)

Stefano Finazzo has played a key role in the development of several Italian American organizations, including the establishment of both the Italian American Club of San Pedro and the Trappeto Club of San Pedro, named after the Italian region of his birth. Instrumental in the Italian government establishing an office in San Pedro, he also served on the committee to preserve the historic Italian Hall. (Courtesy Stefano Finazzo.)

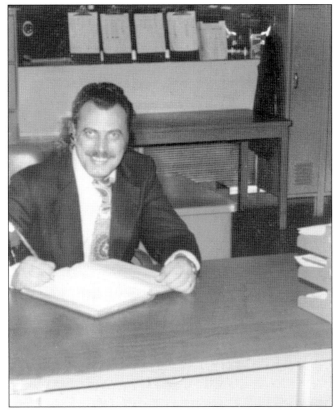

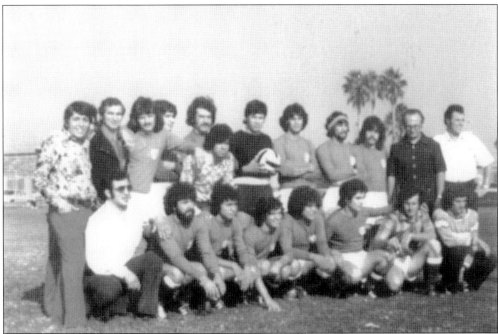

In the 1970s, Finazzo and Gaetano Gambino formed the semiprofessional San Pedro soccer team. Finazzo remained president of the organization for 15 years. (Courtesy Stefano Finazzo.)

This photograph was taken at an award ceremony of the San Pedro Italian American Club in the 1970s. Stefano Finazzo (right) holds a trophy. (Courtesy Stefano Finazzo.)

Finazzo (at center in front of the pizza pan) gathers with friends to root for the Italians at the World Cup final game between Italy and Brazil. Joining him are his sons and friends from the San Pedro soccer team. (Courtesy Stefano Finazzo.)

Instrumental in developing languages classes for children and adults, Stefano Finazzo organized a cultural trip to Sicily for 21 students of Italian heritage. Here unidentified students leave for a month-long trip to Italy funded by the Italian government. (Courtesy Stefano Finazzo.)

Italian American children sing Italian songs in national costumes at a Christmas celebration held by the Italian American Club in San Pedro. (Courtesy Stefano Finazzo.)

Stefano Finazzo performs duties as master of ceremonies at a dinner held in honor of the Archbishop of Morelli, near Palermo, Sicily, who visited Los Angeles and the Casa Italiana. Gemma (left), Stefano's wife, holds a map of Sicily that was given to her husband for his contributions to the Italian community. (Courtesy Stefano Finazzo.)

Diego Brasioli (fourth from left), consul general of Italy in Los Angeles, and Stefano Finazzo (second from left) join members of the Italian American and Trappeto Clubs and several hundred guests to dedicate a portion of Cabrillo Avenue in San Pedro. The area was renamed Via Italia. (Courtesy Stefano Finazzo.)

Seven

ART, CULTURE, AND ENTERTAINMENT

The Italian people living in and around Los Angeles have left their mark of greatness on the cultural realms of visual and performance art, music, literature, and film. This chapter examines some well-known artists in the Los Angeles area as well as a few with less familiar names but an equal wealth of accomplishments.

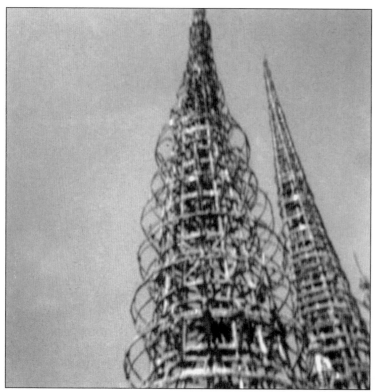

In an out-of-the-way residential neighborhood on 107th Street in South Central Los Angeles are the amazing towers built by Sabato Rodia. Also known as Simon and Sam, Rodia was born in Ribottoli, Italy, in 1879. He immigrated to the United States in 1879 and gradually moved west to California. (Author's collection.)

In 1921, Simon Rodia bought the property in Los Angeles and devoted the following 34 years of his life to building his dream edifice. The reason he told people was simple: he had an idea to do something big and he did it. Every day after his full-time construction job, Rodia would work on his sculpture. Though not trained as a formal architect, he built elaborate arches, fountains, and towering spirals constructed of steel and covered with mortar and colorful mosaic designs. In 1959, structural engineers tested the towers' strength and safety and found that they were secure. (Author's collection.)

The tallest of the towers stands 99.5 feet high. The sculpture garden, built on a triangular-shaped lot in Watts, is now known as the Watts Towers of Simon Rodia. Rodia signed his art in a simple fashion—with the letters S and R. He worked alone without mechanical devices, scaffolding, or welding tools. His only equipment included simple pliers, a belt and buckle, his bare hands, and an imagination. (Author's collection.)

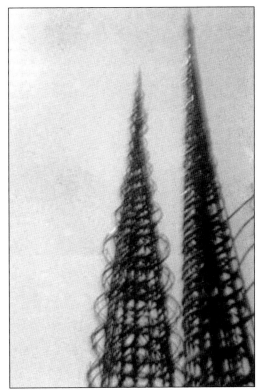

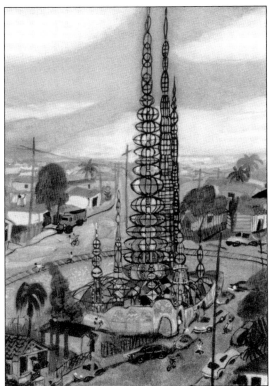

Leo Politi's children's books provide a subtle education through vibrant pictures and simple messages that teach understanding of culture, tradition, and family. In an age where the world is growing ever smaller, it is crucial to appreciate and embrace the beautiful tapestry of multicultural humanity. As a timeless appreciation for the simple things in life, Leo Politi's books unconsciously break down the barriers of prejudice and honor everyone's rich heritage in a down-to-earth manner. Politi captures the work of Italian sculptor Simon Rodia, creator of the Watts Towers, in this painting. Politi's art celebrates the beauty of Los Angeles and the craftsmanship of the towers. (Courtesy Leo Politi family. All Rights Reserved.)

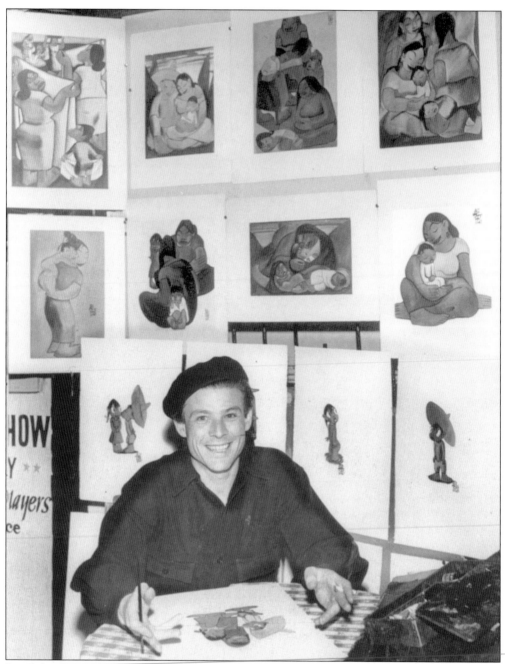

Leo Politi (1908–1996) was born in Fresno of Italian parents and raised in Broni, Italy. When he was 15, he was awarded a scholarship to study at the National Art Institute near Milan. When he was in his 20s, he moved to Los Angeles and lived near Olvera Street. His artwork captures the sights and beauty of Los Angeles in his paints and in his children's book. Two thousand eight marks the centennial of this noted artist. (Courtesy Leo Politi family. All Rights Reserved.)

Politi's career as an artist and illustrator of children's books earned him Caldecott Awards, the highest-ranking award in the publishing industry for children's books. His artwork shows his passion and love of nature, children, and cultural traditions. (Courtesy Leo Politi family. All Rights Reserved.)

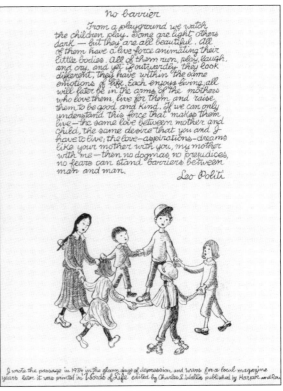

no barrier

From a playground we watch the children play. Some are light others dark — but they are all beautiful. All of them have a live force animating their little bodies. All of them run, play, laugh, and cry, and yet if outwardly they look different, they have within the same emotions of life. Each enjoys living, all will later be in the arms of the mothers who love them, live for them and raise them to be good and kind. If we can only understand this force that makes them live — the same love between mother and child, the same desire that you and I have to live; the love-aspirations-dreams like your mother with you, my mother with me — then no dogmas, no prejudices, no fears can stand barriers between man and man.

Leo Politi

I wrote the passage in 1934 in the gloom days of depression and years later it was printed in *Words of Life* edited by Charles L. Wallis published by Harper and Row for a local magazine

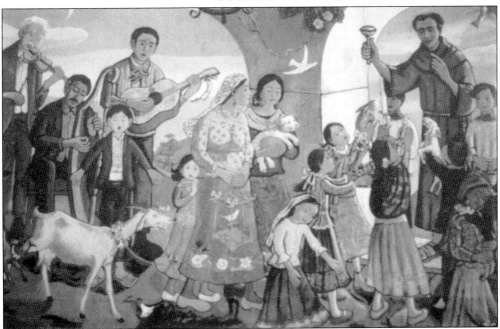

The Blessing of the Animals illustrates the rich Hispanic heritage and religious traditions found in Los Angeles. Children and their parents are pictured bringing pets to the Franciscan priest to receive a blessing. Leo Politi painted the mural depicting this annual Olvera Street event on the wall of the Biscailuz Building in 1977. (Courtesy Leo Politi family. All Rights Reserved.)

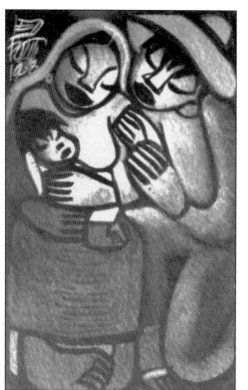

Leo Politi captured the essence of the family in this painting, entitled *Proud Mother and Father*, which he painted in 1938. By painting everyday sights that he viewed on Olvera Street, he was able to earn international acclaim and recognition for his art. (Courtesy Leo Politi family. All Rights Reserved.)

The 1964 book *Bunker Hill* recounts the artist/author's memories of the past days of Los Angeles. Politi used words and illustrations to honor the beautiful Victorian homes that once graced Los Angeles's Bunker Hill. (Courtesy Leo Politi family. All Rights Reserved.)

Angels Flight is an illustration included in the book *Bunker Hill* by Leo Politi. This painting depicts the shortest railway in the world, which opened in 1901. The "Angels Flight" provided a way for people to travel the steep hill between Third and Hill Streets to the fashionable Bunker Hill neighborhood. (Courtesy Leo Politi family. All Rights Reserved.)

Politi painted *Olvera Street* for his 1946 book *Pedro the Angel of Olvera Street*. The book earned a Caldecott Award in children's literature. (Courtesy Leo Politi family. All Rights Reserved.)

Artist Leo Politi sketches Ondo dancers in the Little Tokyo section of Los Angeles during the Nisei Week Celebration. These illustrations were used in the book *Mieko*, written for Golden Gate Junior Books in 1969. In the story, the main character, Mieko, dreams of becoming the queen of the Ondo Parade during the Nisei Week festival in Little Tokyo. (Courtesy Leo Politi family. All Rights Reserved.)

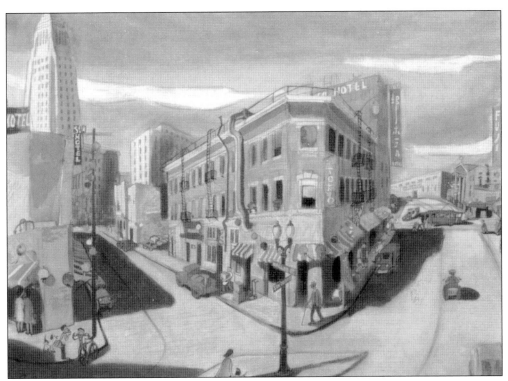

This illustration by artist Politi shows a glimpse of Los Angeles's Little Tokyo. (Courtesy Leo Politi family. All Rights Reserved.)

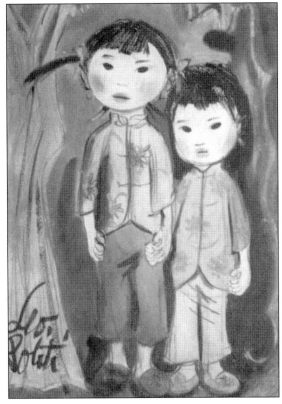

In 1977, Leo Politi painted *Looking in Mr. Fong's Toy Shop* in Chinatown, Los Angeles. (Courtesy Leo Politi family. All Rights Reserved.)

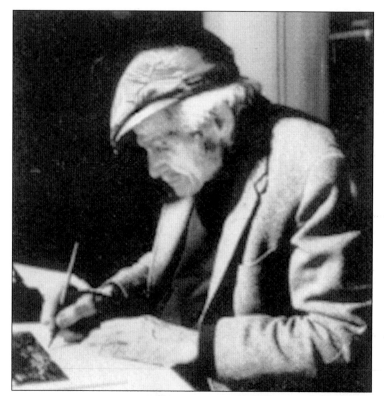

In his familiar cap, artist Leo Politi autographs commemorative lithographs at the reopening of "Angels Flight" in February 1996. The centennial of this creative and loved artist will be marked by many celebrations throughout Los Angeles and his birthplace in Fresno. (Courtesy Leo Politi family. All Rights Reserved.)

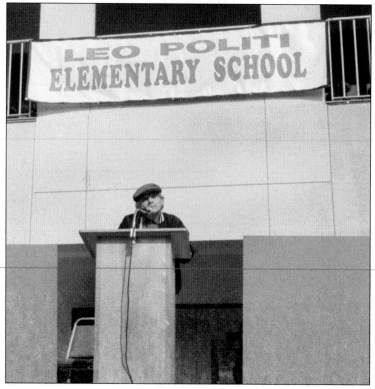

Politi speaks at the dedication of the Leo Politi Elementary School, named in his honor by the Los Angeles Unified School District. Normally the district does not name a school after a living person, so the act serves as a testament to Politi's unquestionable character. (Courtesy Leo Politi family. All Rights Reserved.)

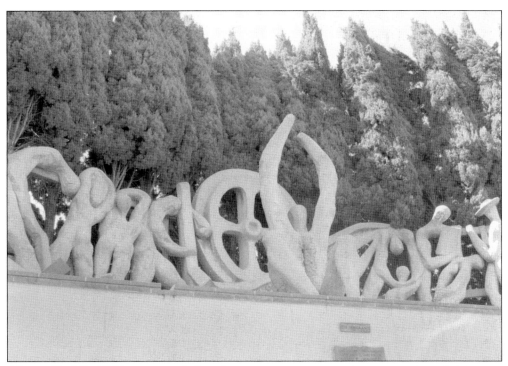

Alberto Biasi (b. 1931) was commissioned in the 1970s to create a sculpture for the Casa Italiana on North Broadway that would depict the realities that Italian immigrants endured when they settled in Los Angeles. The work symbolically shows the struggle, sacrifice, and hard work the immigrants had to endure when they created the Italian community. The sculpture also represents their journey toward a spiritual life, as depicted by the padre on the right. (Courtesy St. Peter's Italian Church.)

Rudolph Valentino (1895–1926), born Rodolfo Guglielmi Castellaneta in Italy, became a suave lover in early Hollywood movies. He is best known for his role as the sheik in *Blood and Sand*. Valentino made 18 movies between 1914 and 1926, when he died at the age of 31. (Courtesy Library of Congress.)

Paul Leo Politi has worked in the recording industry in the genre of R&B music since 1961. He has produced albums that have exceeded over $50 million in sales. In addition, he has written and produced over 40 songs with Barry White that resulted in 12 gold and/or platinum records. He managed and coordinated worldwide licensing for major independent record labels and publishing companies. Paul, the son of artist Leo Politi, also served on the board of directors for six companies. (Courtesy Paul Politi.)

Joseph Sassone, an Italian American transplant to Los Angeles from New Orleans, has been working as an independent producer in Los Angeles for over 20 years. He has produced hundreds of music videos for such well-known artists as Santana, Celine Dion, Missy Elliott, Eric Clapton, Jerry Lee Lewis, Dolly Parton, and Reba McEntire. He has also produced commercials for numerous nationally recognized stores and products. He is currently developing several film projects with strong Italian American themes. (Courtesy Joseph Sassone collection.)

Born in Balestrate, Sicily, Dominic Orlando came to the United States as a small child, first living in Michigan and then moving to the Los Angeles area when he was 10. After studying film at the University of Southern California, he worked as a freelance animator for many of the well-known Hanna-Barbera cartoons. Orlando's early work in animation was a valuable stepping stone to directing music videos. This photograph was taken on location in Malibu for the Beach Boys music video "Getcha Back." (Courtesy Dominic Orlando collection.)

Dominic Orlando directs the crew on location for Cheap Trick's music video "Up The Creek." Also a screenwriter, he is currently working to develop film and television projects with Italian American characters and subject matter. (Courtesy Dominic Orlando collection.)

Dominic Orlando directs a sumo wrestler for Freida Parton's (sister to Dolly) music video for "Oriental Dolls" in the early 1980s. Orlando's credits for directing music videos are comprised of many of the best-known recording artists in the industry, including Reba McEntire, Trisha Yearwood, Dolly Parton, Kansas, the Beach Boys, Cheap Trick, Quiet Riot, Hiroshima, Carly Simon, James Taylor, Rod Stewart, Diana Ross, Vanessa Williams, the Temptations, the Fat Boys, Peabo Bryson, Celine Dion, and Sammy Davis Jr. (Courtesy Dominic Orlando collection.)

Eight

THE WAR YEARS

Wars through history have brought out the best and worst in people. Immigrants transplanted in America shared mixed sentiments for the two lands that they loved and cared enough to go into battle to defend. Italians have assisted in fighting for America's freedom since its inception. This included over 1,000 men that fought in the Revolutionary War. Between 5,000 and 10,000 Italians joined forces in both the North and the South during the Civil War. In World War II, even though an estimated 1.2 million Italian Americans served in the United States military, on the home front many first-generation Italians were looked upon with suspicion and labeled as resident aliens; this was especially true on the West Coast. Stringent restrictions were placed on the roughly 600,000 Italians who had not become citizens as a result of Executive Order 9066, issued by President Roosevelt in February 1942.

Vito Colombo (1895–1967) arrived at Ellis Island from the town of Balestrate in the region of Palermo, Sicily, in 1909. He volunteered to serve in World War I and, as a result, earned his American citizenship. According to the National Italian American Foundation, 87,000 Italian nationals served in the United States military during World War I. After the war, Colombo lived in Pennsylvania and then Detroit before finally settling in Los Angeles in the 1940s. (Courtesy Mary Colombo Schulz.)

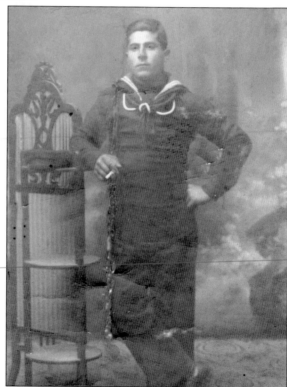

Marco Colombo, Vito's brother, served in the Italian navy during World War I and later immigrated to South America. (Courtesy Mary Colombo Schulz.)

This World War I photograph shows Salvatore Colombo in his Italian army uniform. Just as in the American Civil War, some brothers fought against their own families. Salvatore and Marco fought on the Italian side, while their brother Vito, who had already moved to the United States, served as an Italian national in the U.S. Army. (Courtesy Mary Colombo Schulz.)

Basil Alessandro volunteered to fight in World War II. According to the National Italian American Foundation, 1.5 million Italian Americans served in the United States military during this war. (Courtesy Alessandro family.)

Returning from World War II, Basil Alessandro is greeted by his family. He served his country in the Philippine Islands for the duration of the war. (Courtesy Alessandro family.)

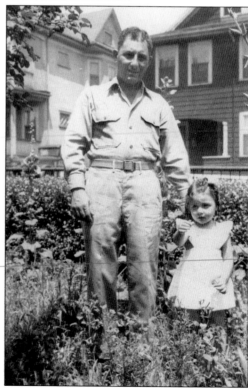

Alessandro enjoys time in the garden with his daughter Carole after coming home from the war. (Courtesy Alessandro family.)

Basil Alessandro is reunited with his wife, Elizabeth, and daughter Carole. During active military duty in World War II, the majority of people enlisted in the armed forces were gone from their families for three or four years without the opportunity to return to the United States until their duty was completed. (Courtesy Alessandro family.)

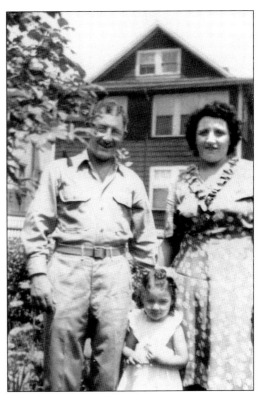

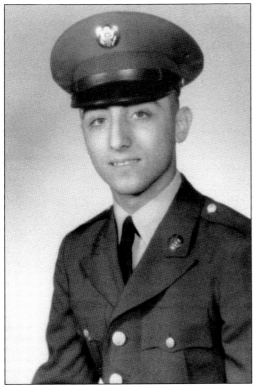

Richard Alessandro followed his father's example and volunteered for active duty during the Vietnam War. Since the time of the Civil War, both Italian nationals and Italian American citizens have engaged in conflict to defend the rights of the United States. (Courtesy Alessandro family.)

WARNING

The Federal Sabotage Act applies to these premises. The attention of all persons is therefore directed to the Federal laws concerning sabotage which prescribe severe penalties for violation thereof.

SABOTAGE

THE FOLLOWING ACTS, AMONG OTHERS, ARE CRIMES AGAINST THE UNITED STATES, PUNISHABLE BY 30 YEARS' IMPRISONMENT, $10,000 FINE, OR BOTH

a. Deliberately doing any act which may injure, interfere with, or obstruct the United States or any allied nation in carrying on the war, by injuring or destroying war material, war premises, or war utilities.

b. Deliberately injuring, interfering with, or obstructing the United States or any allied nation in carrying on the war, by making or causing to be made in a defective manner, any war material or any article used in the making or repairing of any war material.

TREASON IS PUNISHABLE BY DEATH!

Warning, sabotage: treason is punishable by death! Posters issued by the U.S. government during World War II were displayed in post offices. Restrictions were placed on speaking Japanese, German, and Italian in public because it was the language of the enemy and it was possible that anti-American information could easily be shared in a foreign language. Most Italian language schools were closed during the war years. (Courtesy Northwestern University, www.library.northwestern.edu/govpub/collections/wwii-posters/img/ww0207.)

This World War II photograph shows an internment camp in Fort Missoula, Montana. About 1,600 Italian citizens were interned and approximately 10,000 Italian Americans were forced to leave their homes in California coastal cities and move inland. Nearly 600,000 legal Italian immigrants were imposed with travel restrictions. Curfew rules were enforced, as well as rules denying the owning of cameras, shortwave radios, and other devices that could alert the enemy. Southern California Italians taken into custody during World War II included the following: radio broadcaster Filippo Fordelone; Giovanni Cardellini, secretary of the exterior; Combattenti Spartaco Bonomi, editor of *La Parola*; Dr. Giovanni Falasca; and Capitano Zaccaria Lubrano, assistant editor of *La Parola*. (Courtesy Gloria Ricci Lothrop, Ph.D.)

NOTIZIARIO DELLE NAZIONI UNITE

Le donne dei Paesi Alleati

lavorano e lottano

per affrettare la vittoria

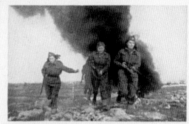

GUERRIGLIERE JUGOSLAVE, *veterane della lotta contro i nazi e rotte a tutte le asprezze della guerra, che avanzano verso una nuova posizione in Italia.*

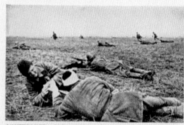

INFERMIERE *addette al Corpo di Spedizione francese in Italia, intente a sterilizzare ferri chirurgici entro il raggio d'azione dei cannoni tedeschi.*

PRONTA PER IL VOLO! *Giovane milite del Corpo Ausiliario Femminile della RAF, al quale è oggi affidato in buona parte il collaudo degli apparecchi.*

L'INFERMIERA OLGA USSOVA *si trascina carponi sul campo per portare aiuto sanitario ad un soldato russo ferito. Essa ha portato a salvamento 12 feriti.*

MILITE DELLA RISERVA FEMMINILE *della Marina americana che, dalla torre di controllo di una base navale sull'Atlantico, osserva il traffico aereo.*

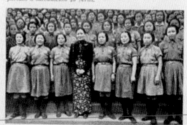

GIOVANI CINESI DELLA MILIZIA VOLONTARIA FEMMINILE *pronte a tutto per scacciare dalla patria l'invasore. Al centro del gruppo, la Signora Ciang-Kai-scek.*

NO. 3 PUBBLICATO DALL'UFFICIO INFORMAZIONI DI GUERRA DEGLI STATI UNITI D'AMERICA

Notiziaro delle Nazioni Unite is a World War II poster from the United Nations/United States Office of War Information. It shows women working in the military as volunteers and in civilian occupations that supported the United States's goals of peace and victory. (Courtesy Northwestern University, www.library.northwestern.edu/govinfo/collections/wwii-posters/index.html.)

Nine

KEEPING THE ITALIAN CULTURE ALIVE

Although there is no physical Little Italy in Los Angeles, the Italian culture is thriving. At this writing, more than 70 Italian American organizations actively honor the Italian ancestry in a variety of ways. Over one million Italian Americans live in California. Italian Americans have made significant contributions in every aspect of life in the United States, including government, law enforcement, music, art, literature, business, education, science, sports, and entertainment. New immigrants, as well as second- or third-generations, keep alive the tradition that with hard work nothing is impossible in America.

The new Los Angeles San Gennaro Festival brings together people of all ethnic backgrounds to enjoy great food, an East Coast Italian atmosphere, and live entertainment. The three-day event begins with the celebrity-filled *Prima Notte* (First Night), a benefit fund-raiser for underprivileged children in the Los Angeles area. Other events include food booths, art, and music, all related to celebrating the Italian culture. (Author's collection.)

Jimmy Kimmel, late-night host of *Jimmy Kimmel Live* and the successful *Man Show* and cocreator of the *Crank Yankers* cable show, was born of Italian-German heritage and grew up in New York and Las Vegas. He cofounded the Los Angeles Feast of San Gennaro and the San Gennaro Foundation to perpetuate a cultural identity in the Italian American community. Notable and cofounding members of the San Gennaro Foundation include the following: chairman Doug DeLuca; vice-chairman Jimmy Kimmel; president Gregg Cannizaro; vice presidents Frankie Competelli, Joe Cerrell, Fred Tredy, Art Grenci, Elvis Restaino, Victoria Dolceamore, and Mike Marino; secretary Mario Macaluso; and treasurer Gina Kimmel. The festival began in 2000 and continues to grow into a major Los Angeles event filled with entertainment, vendors, and the smells of delicious Italian foods. (Courtesy San Gennaro Foundation.)

Doug DeLuca, the producer of *Jimmy Kimmel Live*, is a talented producer with a variety of feature films, television specials, music videos, and live theater to his credit. DeLuca is the cofounder and chairman of the nonprofit San Gennaro Foundation. Through his passion for Italian culture and his sense of family and tradition, the San Gennaro Festival is presented to 10,000 visitors every year over a fall weekend. DeLuca is currently working on new projects related to the awareness of Italian culture in Los Angeles. (Courtesy San Gennaro Foundation.)

Tony and Giovanna DiBona created the authentic Italian dance troupe Roman Holiday. The couple formed the group several years ago to preserve the musical heritage that Italians Americans brought to this country. Tony is a first-generation Italian, as his parents were born in Sicily. Both Tony and Giovanna were raised with exposure to Italian culture, language, customs, and music. (Courtesy Giovanna DiBona.)

San Gennaro is the patron saint of Naples, Italy. He was a bishop who was beheaded during the reign of emperor Diocletian in 305 AD. For over 600 years, followers have believed that his dried blood miraculously liquefies on his feast day, September 19, and on the first Saturday in May. People offer money donations to the saint to accompany prayer requests or in thanksgiving for blessings received. Donations are given to local charities. J. B. Griffin, the publisher of *So Cal Italian Magazine*, offers a donation at the statue of San Gennaro at the Los Angeles San Gennaro Festival. (Courtesy J. B. Griffin.)

Giovanna DiBona produces the shows presented by the group Roman Holiday. Audience members have the opportunity to sing and dance along to traditional and lively Italian songs. Giovanna is a first-generation Italian, as her parents immigrated from the Molise area of Italy. (Courtesy Giovanna DiBona.)

Giovanna DiBona and Filippo Voltaggio wear authentic Italian costumes and sing traditional Italian songs and ballads. The musical troupe Roman Holiday is composed of five musicians and four dancers. (Courtesy Giovanna DiBona.)

Grape Stomp dancers Nanetta Hupp (left) and Nancy DiMartino (right) have a good time presenting old Italian traditions. (Courtesy Giovanna DiBona.)

From left to right, Norm Pantos, Giovanna DiBona, and vocalist Filippo Voltaggio re-create authentic Italian entertainment at a festival held across the nation. (Courtesy Giovanna DiBona.)

Giovanna DiBona (left) and Jennie Prima entertain at the Prima Notte gala evening of the San Gennaro Festival. Giovanna designs all the colorful Italian costumes worn by members of Roman Holiday. (Courtesy Giovanna DiBona.)

Nanetta Hupp rekindles the tradition of Italian peasant women stomping grapes in preparation for wine making. (Courtesy Giovanna DiBona.)

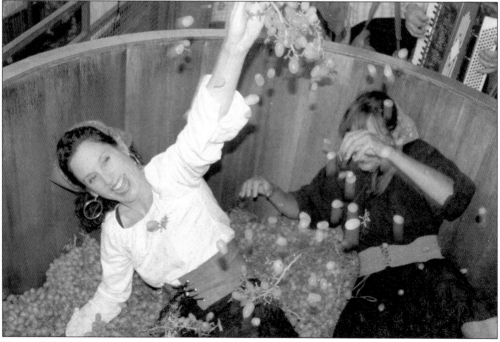

Nancy DiMartino, a member of Roman Holiday, joyfully stomps on grapes in a barrel with her bare feet. The dance group performed in the movie A *Walk in the Clouds* in a scene featuring a grape festival with Italian singing and dancing. (Courtesy Giovanna DiBona.)

In 1984, the Italian Ministry of Foreign Affairs established the Italian Cultural Institute in Los Angeles, one of five cultural agencies established in the country. The institute offers Italian language classes, art exhibitions, film screenings, and special events. Its authority covers Southern California, Nevada, Arizona, New Mexico, Arkansas, Louisiana, Oklahoma, and Texas. The institute is located in Westwood Village, close to the University of California, Los Angeles.

Silvano Mizrahi, president of La Piazza Cultural Center in San Pedro, and vice president Stefano Finazzo work to build a lasting structure that will honor the accomplishments of Italian Americans in the Los Angeles Harbor area. The multilevel building will be modeled after the Piazza Navona in Rome. Plans include a convention center, a movie theater for foreign films and live performances, a library, and a museum. The goal of the nonprofit La Piazza project is to teach and preserve the Italian tradition for future generations. *Una piccola Italia nel cuore di San Pedro,* or "A Little Italy for everybody in San Pedro." (Courtesy Stefano Finazzo.)

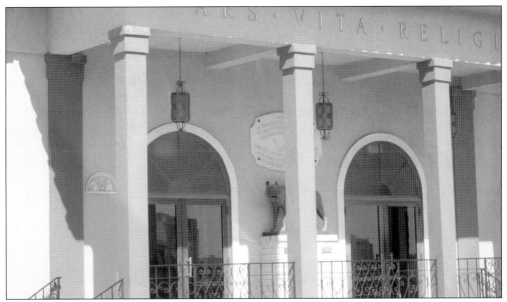

Casa Italiana is a large modern hall adjacent to St. Peter's Italian Church, near downtown Los Angeles. In the early 1970s, the hall was rebuilt with the leadership of the Scalabrini Fathers under the direction of former pastor Fr. Luigi Donanzan. A meeting place for various Italian organizations, it is also home to the Casa Italiana Opera Company. A plaque outside the Casa Italiana reads, "*Gli Italiani*, The Italians—a people of poets and artists, of heroes and saints, of thinkers and scientists, of migrants and navigators." (Courtesy St. Peter's Italian Church.)

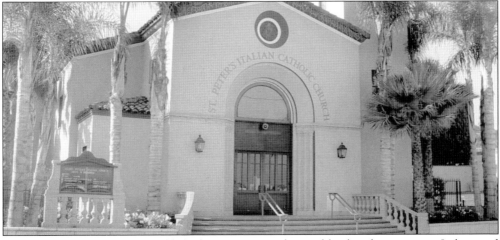

St. Peter's Italian Church, established in 1904, provides weekly church services in Italian and sponsors many religious festivals and celebrations. The Italian culture is kept vibrant at St. Peter's through the many organizations that hold functions at the facility, including the following: the San Trifone Society, also known as the Societa Cattolica Pugliese Di Beneficenza; the St. Anthony Society; the Patron Saints of Adelfia Canneto; the Maria Ssma. di Costantinopoli Society; Famiglia del Sacro Cuore di Gesu' Society; the Santa Lucia Society; the Italian Catholic Federation; the Calabria Club; Abruzzesi Molisani di California; Association Piemontesi Nel Mondo; Associazione Pugliese Del Sud California; the Italian Woman's Club; La Fameja Veneta; the order of Sons of Italy in America; the Patrons of Italian Culture; Societa Bosconerese di Los Angeles; the Los Angeles chapter of Unico; and Fondazione Italia. (Courtesy St. Peter's Italian Church.)

ACROSS AMERICA, PEOPLE ARE DISCOVERING SOMETHING WONDERFUL. *THEIR HERITAGE.*

Arcadia Publishing is the leading local history publisher in the United States. With more than 3,000 titles in print and hundreds of new titles released every year, Arcadia has extensive specialized experience chronicling the history of communities and celebrating America's hidden stories, bringing to life the people, places, and events from the past. To discover the history of other communities across the nation, please visit:

www.arcadiapublishing.com

Customized search tools allow you to find regional history books about the town where you grew up, the cities where your friends and family live, the town where your parents met, or even that retirement spot you've been dreaming about.